Drawing in Color

PEOPLE & PORTRAITS

Lee Hammond

NORTH LIGHT BOOKS
CINCINNATI, OHIO
www.nlbooks.com

Acknowledgments

As I begin to write the manuscript for this book (my ninth with North Light), I cannot help but reflect on what a lucky human being I am. I remember long ago, when my goal was to have my *first* book published. Now, thanks to all of my readers, who made it a success, I am able to continue with what I love: Teaching others to draw, using my own textbooks. So, to all of you who are buying my books, a huge THANK YOU!

It goes without saying how much the people at North Light Books mean to me. Thank you, Greg Albert, for understanding the events of my life and still placing faith in me as an author.

Drawing in Color: People & Portraits. Copyright © 2000 by Lee Hammond. Manufactured in China. All rights reserved. No part of this book may be reproduced in any form or by any electronic or mechanical means including information storage and retrieval systems without permission in writing from the publisher, except by a reviewer, who may quote brief passages in a review. Published by North Light Books, an imprint of F&W Publications, Inc., 1507 Dana Avenue, Cincinnati, Ohio, 45207. First edition.

04 03 02 01 00 5 4 3 2 1

Library of Congress Cataloging in Publication Data

Hammond, Lee
 People & portraits / Lee Hammond.—1st ed.
 p. cm.—(Drawing in color)
 Includes index.
 ISBN 1-58180-038-X (alk. paper.)
 1. Colored pencil drawing — Technique. 2. Portrait drawing—Technique.
 I. Title: People and portraits. II. Title. III. Series.
NC892 .H365 2000
743.4--dc21 00-029214
Edited by Nancy Pfister Lytle
Production Edited by Nancy Pfister Lytle
Designed by Wendy Dunning
Production Coordinated by Mark Griffin

Dedication

This book is dedicated to my husband, Sam. Thank you from the bottom of my heart for coming into a life that made little sense and turning it into a journey worth taking.

I would also like to dedicate this book to my cousin's wife, Cathy Sigler, who lost a battle with leukemia in October. I had the privilege of getting to know her while living in Portland, Oregon. Our family has lost a sweet soul. My heart goes out to you all.

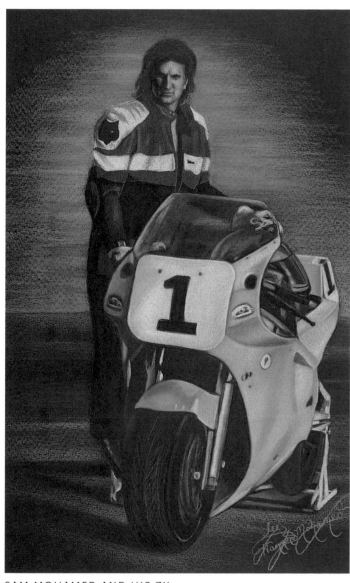

SAM MOHAMED AND HIS ZX7
Prismacolor on Black mat board
16" x 20" (41cm x 51cm)

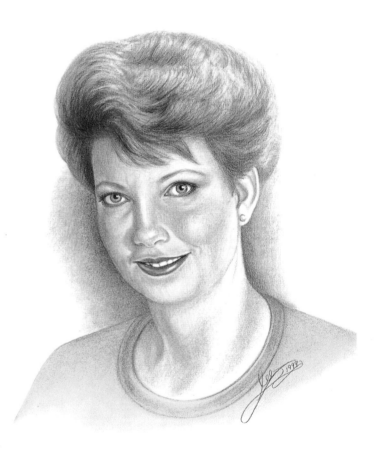

CATHY LYNN SIGLER 1953-1999
Col-erase on Ivory mat board
16" x 20" (41cm x 51cm)

About the Author

Polly "Lee" Hammond

Polly "Lee" Hammond is an illustrator and art instructor from the Kansas City area. She owns and operates the Midwest School of Illustration and Fine Art, Inc., in Lenexa, Kansas, where she teaches realistic drawing and painting.

Lee was raised and educated in Lincoln, Nebraska, and built her career in illustration and teaching in Kansas City. Although she has lived all over the country, she will always consider Kansas City home.

Lee has been an author with North Light Books since 1994. She also writes articles for other publications such as *The Artist's Magazine* and *Kansas City Sports Magazine*.

Lee is continuing to develop new art instruction books for North Light and is also expanding her career into children's books, which she will also illustrate. Recently remarried to Sam Mohamed, she is sharing his love of motor sports and beginning a new aspect of her career by illustrating various types of racing. Limited-edition prints of celebrity racing figures will soon be offered.

Lee is the mother of three children: Shelly, LeAnne and Christopher. She has two grandchildren: Taylor and Caitlynn.

Table of Contents

Introduction

Drawing in colored pencil is truly one of my favorite mediums and is one of the most popular techniques I teach in my art studio. However, it wasn't always that way. My first attempts at colored pencils were weak and frustrating, resembling crayon drawings more than finished pieces of artwork. As much as I hate to admit it, I gave up instead of forging ahead and learning from my mistakes. Remarkably, years after I attempted it, I suddenly woke up with the understanding of what I was doing wrong and gave it another shot. Amazingly enough, my newfound insight was correct! It was then that I began the wonderful journey of being a colored pencil artist.

When a student comes to me to learn to draw in color, I remember what happened to me. Hopefully, I can prevent someone else from learning the hard way.

This book is designed to teach the various techniques associated with different types of colored pencils. There are many types of pencils available, each with their own characteristics: Each one will produce a different look. To know which pencil to use, you must first decide which look you want your artwork to have. No one brand of pencil will do it all for you.

I have designed this book to give you a good understanding of the various pencils and the techniques and outcomes achievable with them. I've even created some new techniques that haven't been published before! I've provided color names for you to use as a guide, as well as step-by-step projects to provide you with practice.

I encourage you to try as many of these pencils and techniques as possible, because there is truly no limit to the things you can realistically draw with colored pencils. This book will be the first in a series of books I will be writing, dedicated solely to colored pencil techniques. These books will focus on the use of the pencils themselves, the subject matter and the techniques you must use to achieve success. This book will focus on using colored pencils to draw people. I encourage you, however, to refer to some of my other books for more specialized coverage of subjects such as facial features (*Lifelike Portraits* and *Draw Real People*), hands (*Draw Real Hands*) and clothing (*Draw Fashion Models*). All of my books work together to give the beginning artist a solid understanding of how to draw things accurately.

Be persistent and practice: Practice will be the key to your artistic success.

Have Fun!

I am excited for anyone who wants to learn the wonderful world of colored pencil drawing, for it will truly open up a whole new world of artistic possibilities. From subtle, soft pastel impressions to bright and bold color statements, such as the illustration below, colored pencil drawing is as versatile as it comes. The possibilities are as endless as your imagination!

Gather your materials and get ready for an exciting ride into the world of colored pencil.

SHANE CLARK
Prismacolor on White illustration board
16" x 20" (41cm x 51cm)

You Can Do It!

As I mentioned in the introduction, each brand of pencil has its own characteristics. But not only that, each technique has its own "feel." As a beginner learning these techniques, you may be frustrated at first. This is perfectly normal. I think this frustration stems from not knowing what to expect. It is not unusual for your first attempts to appear childish: Sometimes your work will resemble a crayon drawing. It is very difficult for those who have been taught my graphite techniques first, and the realism achieved with that method, to try to get the same outcome right away with colored pencil. Be patient. The more you practice, the more you will learn to understand this wonderful artistic medium.

Let me guide you, step by step. The following is an example of what a student of mine experienced. As you can see, her first attempt was frustrating, but with a little guidance and experience, her final project was beautiful. You, too, can have the same results.

This book will help you develop the skills you need, from knowing which pencil to choose to understanding which paper will help you achieve the look you want. It will show you how different all of the pencil brands are and how to use each one in a different manner. Colored pencils have a feel to them. I will show you how to recognize it and use it to produce some of the best artwork you've ever done!

This is an example of the work of a typical beginner. The tones are choppy, with many pencil lines still showing. Although the colors used aren't bad, the tones have not been built up to look realistic.

Also, this was done freehand. The shapes are close but not accurate. The face has been drawn straight on, not turned like the following example.

Artwork by Kay Watkins

This is what the student was able to do with a little guidance. By using measurements and a projector, the accuracy of the features and pose is much better.

The colors were built up and then blended with a tortillion to create the smoothness of the skin tones. Studio pencils were used for this.

The bright red of the dress was achieved with Prismacolor and a heavy application of tone. The hair was done with layers of Studio pencils, using a sharp point. A hint of Aqua, blended into the background, makes the colors stand out.

Don't Give Up

Remember, I gave up on using colored pencil because my beginning drawings didn't work out. You may be thinking the same thing: "This is all too confusing!" Please: Don't give up. Let me guide you. I'll break it down into easy-to-understand recipes for artistic success. In no time at all, you too will be drawing realistically with colored pencil. It will be worth the effort. The following pages will prove it!

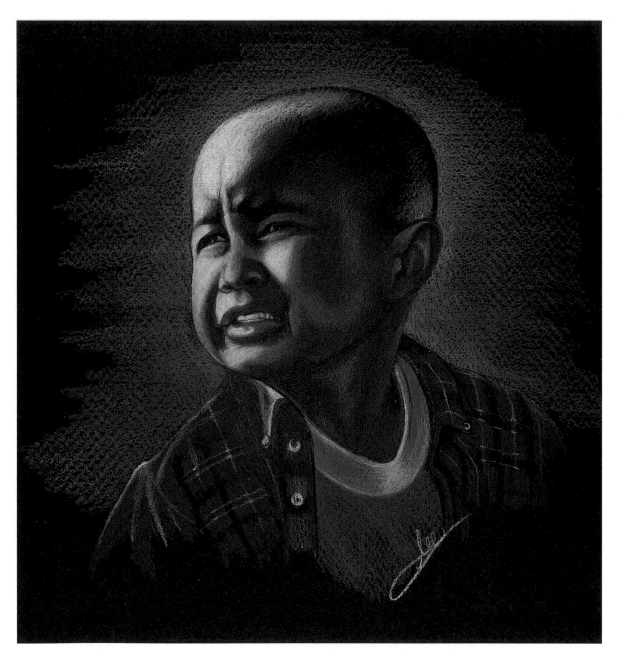

PORTRAIT OF A
LITTLE BOY
Prismacolor on Black
mat board
16" x 20"
(41cm x 51cm)

Getting Started

Using the Proper Pencils

Each brand of colored pencil has a different appearance when used. Each pencil is made differently to create a different effect. When asked which pencil is "the best," or which one I like the most, I've been given a question that I can't answer easily. It really depends on the final outcome and the "look" I want my work to have. Rarely will I use just one brand of pencil to complete a project. Any one of them alone is somewhat limited. I have found that by using a combination of pencils, I can create more variety in my techniques. This enables me to achieve the look I'm trying to accomplish. The following is an overview of the six types of pencils I like the most.

PRISMACOLOR

These pencils have a thick, soft, wax-based lead that provides a heavy application of color. They are opaque and will completely cover the paper surface. They are excellent for achieving smooth, shiny surfaces and brilliant colors. The colors can be easily blended together to produce an almost "painted" appearance to your work. They come in a huge selection of colors: 120 or more.

VERITHIN

Verithins are also wax-based lead, but have a harder, thinner lead than the Prismacolors. Because of their less waxy consistency, they can be sharpened to a very fine point. They are compatible with Prismacolor but are more limited in their color range, which is forty-eight. I use Verithin whenever I want the paper to show through because they cannot build up to a heavy coverage. They can give you very sharp, crisp lines. They are good for layering colors without the colors mixing together. The Prismacolors can give your work a painted appearance; the Verithins give your work more of a "drawn" look.

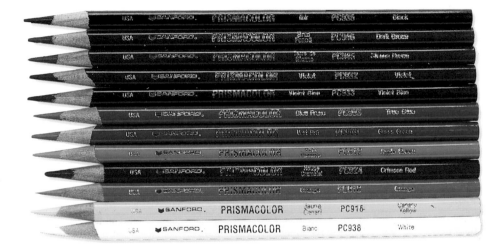

Prismacolor pencils

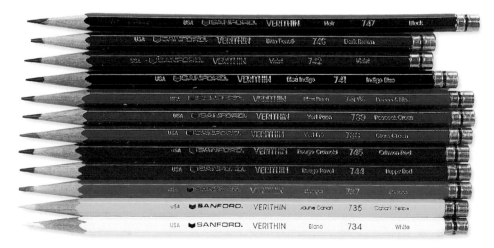

Verithin pencils

COL-ERASE

Unlike Prismacolor and Verithin, this brand of pencil can be easily erased. It can also be blended with a stump or tortillion, giving it the look of pastel. Although these pencils have a limited palette of colors (twenty-four), the ability to blend colors together makes them quite versatile. They also can be sharpened into a fine point, but due to their powdery consistency it is hard to achieve extreme darks. Left unsealed, without applying a fixative, they look like pastel. Spray them with fixative, and they can resemble watercolor.

STUDIO PENCILS

This brand of pencil, by Derwent, is somewhat like a composite of the other brands. It is a clay-based pencil with a range of seventy-two colors. Applied heavily, it can create deep, dark hues. Applied lightly, it can be blended with a tortillion. It also has a sister pencil called the "Artists" line, which is the same formulation with a bigger lead diameter. I use the Studio line because I prefer a sharper point. Also, because it is clay based it will not build up color as well as Prismacolor and will give more of a "matte" (nonglossy) finish.

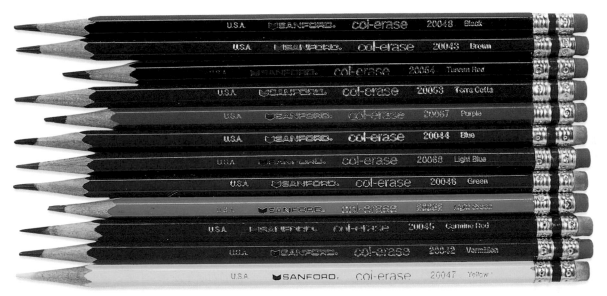

Col-erase pencils

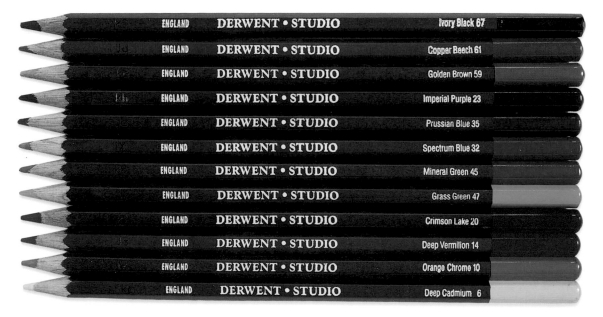

Studio pencils

WATERCOLOR PENCILS

Watercolor pencils are a unique artistic tool that can be used to combine the techniques of drawing and painting. They contain actual watercolor pigment put into a pencil form. They can be used to draw with, just like any other colored pencil. But with the application of a little water and a paintbrush, the pigment dissolves into paint, changing the look entirely. These are a fun break from traditional colored pencils.

NEGRO PENCILS

Using this clay-based black pencil is an excellent way to achieve deep, rich black in your work without a hazy wax buildup. This is the blackest pigment I've ever found in a colored pencil. It comes in five degrees of hardness, ranging from soft (1) to hard (5).

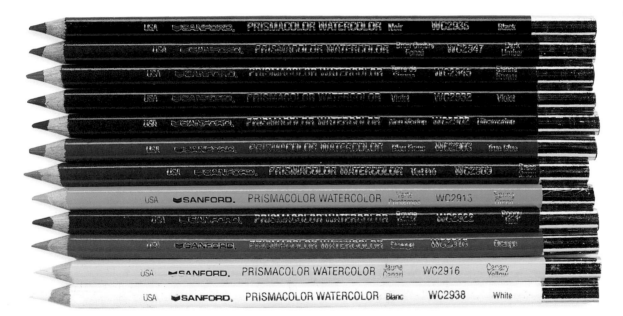

Watercolor pencils

Negro pencils

Tools of the Trade

As with anything we do, the quality of our work is determined by the quality of the tools we employ for the job. Artwork in colored pencil is no different. The following is a list of supplies you will need to succeed.

PAPER

The paper you use with colored pencils is critical to your success. There are many fine papers on the market today. You have the option of choosing from hundreds of sizes, colors and textures. As you try the various types, you will undoubtedly develop your own personal favorites.

Before I will even try a paper for colored pencil, I always check the weight. Although there are many beautiful papers available, I feel many of them are just too thin to work with. I learned this the hard way, after doing a beautiful drawing of my daughter, only to have the paper buckle when I picked it up. The crease formed was permanent, and no amount of framing kept my eye from focusing on it first. From that point on, I never used a paper again that I could easily bend when picked up. The more rigid, the better! Strathmore has many papers that I

Prismacolor on mat board

Prismacolor on suede board

Strathmore Renewal paper has soft colors with the look of tiny fibers in it.

Artagain, also by Strathmore, has a speckled appearance and deeper colors. Both have a smooth surface.

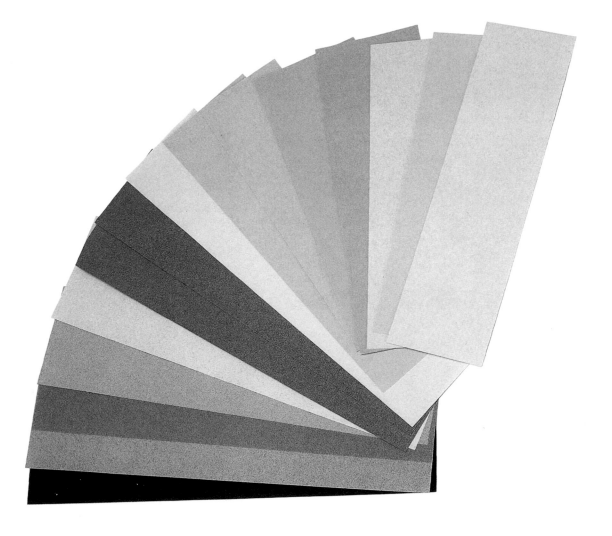

use often. The following is a list of the ones I personally like to use the most and recommend to my students.

Artagain — Artagain is a recycled paper by Strathmore that has somewhat of a flannel appearance to it. It is a 60-lb. (130gsm) cover-weight paper, which comes in a good variety of "dusty colors" as well as black and white. Although it has a speckled appearance, it has a smooth surface without a noticeable texture. It comes in both pads and single sheets for larger projects.

Renewal—Renewal is another Strathmore paper, very similar to Artagain, but it has the look of fibers in it instead of speckles. I like it for its soft earth tones.

Crescent Mat Board—This is my personal favorite because of the firmness of the board. It is already rigid and doesn't have to be taped down to a drawing board. This makes it very easy to transport in a portfolio. Its wide range of colors and textures are extremely attractive. Not only do I match the color to the subject I am drawing, I will often use the same color of mat board when framing the piece to make it color coordinated.

Crescent Suede Board—This has also become one of my favorites. It has a surface like suede or velveteen. I have developed a technique using Prismacolor that makes it look like pastel when applied to this fuzzy surface.

PENCIL SHARPENERS

Pencil sharpeners are very important with colored pencils. Later in the book, you will see how many of the techniques require a very sharp point at all times. I prefer an electric sharpener, or a battery operated one when traveling. A hand-held sharpener requires a twisting motion of the arm. This is usually what breaks off the pencil points. The motor-driven sharpeners allow you to insert the pencil straight on, reducing breakage. If you still prefer a hand-held sharpener, spend the extra money for a good metal one, with replacement blades.

ERASERS

I suggest that you have three different erasers to use with colored pencil: a kneaded eraser, a Pink Pearl eraser and a typewriter eraser. Although colored pencil is very difficult, if not impossible, to completely erase (except for Col-erase), the erasers can be used to soften colors as you draw.

The kneaded eraser is like a squishy piece of rubber, good for removing your initial line drawing as you work. It is also good for lifting highlight areas when using the Col-erase pencils. (I'll show you later.) Because of its soft, pliable feel, it will not damage or rough up your paper surface.

The Pink Pearl eraser is a good eraser for general cleaning. I use it the most when I am cleaning large areas, such as backgrounds. It, too, is fairly easy on the paper surface.

The typewriter eraser looks like a pencil with a little brush on the end of it. It is a highly abrasive eraser, good for removing stubborn marks from the paper. It can also be used to get into tight places or to create clean edges. However, great care must be taken when using this eraser, because it can easily damage the paper and leave a hole.

MECHANICAL PENCIL

I always use a mechanical pencil for my initial line drawing. Because the lines are so light, unlike ordinary drawing pencils, they are easily removed with the kneaded eraser; as you work, replace the graphite with color.

TORTILLIONS

These are cones of spiral wound paper. They are used to blend after you have applied the color pencil to the paper. I use them only with Col-erase and Studio pencils. Prismacolor is much too waxy for this technique. Verithins work somewhat, but don't blend as evenly as the clay-based pencils.

ACETATE GRAPHS

These are overlays to place over your photo reference. They have a grid pattern on them that divides your picture into even increments, making it easier to draw accurately. I use them in both 1" (2cm) and ½" (1cm) divisions. They are easy to make by using a permanent marker on a report cover. You can also draw one on paper and have it copied to a transparency on a copy machine.

TEMPLATES

These stencils are used to obtain perfect circles in your drawing. I always

use one when drawing eyes to get the pupils and irises accurate.

MAGAZINES

The best source for drawing material is magazines. I tear out pictures of every subject and categorize them into different bins for reference. When learning to draw, they can provide a wealth of subject matter. When drawing people, there is nothing better than glamour magazines.

CRAFT KNIVES

Craft knives are not just for cutting things: They can actually be used as a drawing tool. When using Prismacolor, I use the edge of the knife to gently scrape away color to create texture such as hair or fur. It can also be used to remove unwanted specks that may appear in your work. As you can probably imagine, it is important to take care with this approach to avoid damaging the paper surface.

Technique

There are many ways to approach drawing people with colored pencil. The technique you employ depends on many factors. First, what look do you want your artwork to have? I mentioned before that using different brands of pencils, and using them on certain paper stocks, would achieve different looks. The same drawing can be done many ways, with each one looking quite different. These examples of Abe Lincoln show how different the black Verithin drawing looks when compared to one done in watercolor pencils.

The best way to learn the different techniques is to try the various pencils and practice drawing some value scales. It is a good way to learn to control the way you hold the pencil and to control the tones from dark to light. It will also give you the feel of each brand.

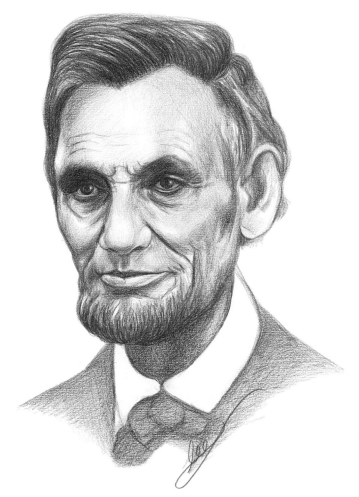

Abraham Lincoln drawn with a Black Verithin pencil.

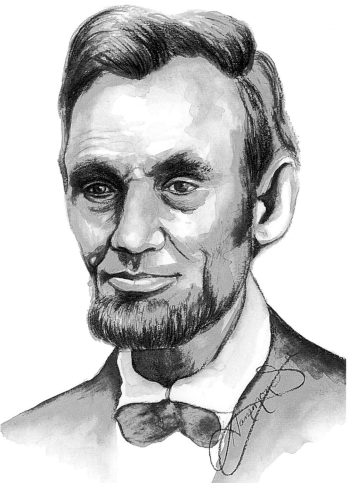

Abraham Lincoln drawn with a Brown watercolor pencil.

Using the Layering, Burnishing and Blending Techniques

LAYERING

I like to start my students out with Verithin first, to learn the layered approach, a technique that will carry over to the other brands as well. Layering is a process of using a very sharp point on the pencil and applying the tone gently and evenly. Do not let your pencil point become dull: This alters the line width and gives a crayon-like look to your drawing.

Colored pencil has a "feel" to it. When doing darker areas, I have a tendency to hold the pencil closer to the tip; this allows me to apply more pressure. As I move into lighter areas I pull back, holding the pencil farther back from the tip. This helps me touch the paper surface lightly, giving me more control and a more even application.

Your blend should be very gradual as it fades from dark to light. There should be no choppiness between tones, no definite line where one tone ends and the other begins. Practice many value scales. The more you do, the better you will become. Start with just a Black pencil at first, layering from dark to light by altering the pressure applied to the pencil. Then try going from dark to light with colored pencils.

BURNISHING

Once you are comfortable with the layered approach, try Prismacolor. Let's begin with Black, Cool Gray and White. This process will begin the same as layering, but you will continue to build up the color until it completely covers the paper surface. This is where you will use burnishing; a technique in which you use a lighter color to blend the darker colors in evenly. For example, start with Black and then apply Cool Gray next to, and overlapping, the Black. The lighter color going into the dark will soften the two together. Then add White into, and overlapping, the

Colored pencil should always be applied with smooth, even pencil strokes and a very sharp point. This will keep your tones even and your work looking neat.

Note — When burnishing with Prismacolor, a sharp point is not necessary.

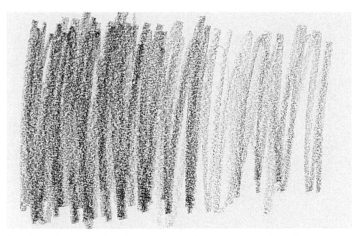

Don't apply pencil lines in a scribbled fashion: This will make your work look sloppy. Do not let your pencil point become dull. It will look like crayon when applied.

Cool Gray. Continue burnishing the colors, alternating the addition of dark and light, until they appear smooth and transitional. Prismacolor drawing is a process of applying many colors, each one into the others, using the lighter of the colors to burnish. Sometimes you may have to layer and burnish many times to get the look you want. This technique requires a lot of patience. The nice thing is that burnishing is best done with a dull pencil point.

BLENDING

Blending is the application of tone and color in a smooth gradual manner. Each tone should fade into the next with no choppiness or obvious separation between them.

The following examples show the same practice work using the types of pencils. Notice how each one has its own look and its own personality. The more pencils you try, the more versatile you will be as an artist.

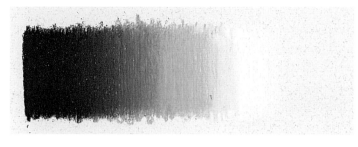

A value scale in Prismacolor pencils (burnished)

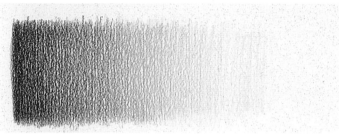

A value scale in Verithin pencils (layered)

A value scale in Col-erase pencils (blended)

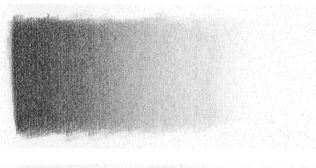

A value scale in Derwent Studio pencils (blended)

A value scale in watercolor pencils (washed)

The Five Elements of Shading

THE SPHERE

Whenever I teach a new technique, I begin with the sphere. This simple shape is the foundation for everything you will draw. Its rounded shape teaches you everything you need to know about creating the illusion of form. One of the most important keys is the way to draw edges.

The *sphere* provides an example of the five elements of shading. Without all five elements being present in your work, your drawing will appear flat. Study the examples and the five definitions carefully. Commit the definitions to memory. Think about them whenever you draw. This is one of the most important keys to successful drawing or painting. It applies to all mediums and subject matter.

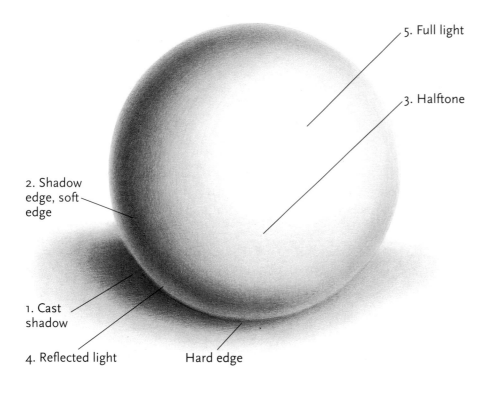

5. Full light

3. Halftone

2. Shadow edge, soft edge

1. Cast shadow

4. Reflected light

Hard edge

A SPHERE SHOWING THE FIVE ELEMENTS OF SHADING

1. Cast shadow. The darkest element, where light is not present

2. Shadow edge. Where the curve of the ball creates a shadow

3. Halftone area. The true color of the ball, with no highlight or shadow

4. Reflected light. Where the light from behind and below bounces up on the edge of the ball, separating the ball from the shadow on the table

5. Full-light area. Where the light source is the strongest

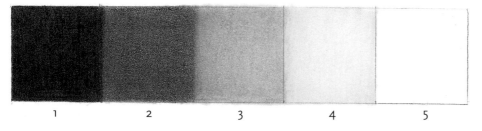

1 2 3 4 5

These values correspond, in order, to the five elements of shading.

THE CYLINDER

The *cylinder* is also an important shape that applies to many things we draw. Look at how the five elements of shading can also be seen here.

Using Verithin and Prismacolor pencils, again in the gray tones, practice drawing the five elements of shading with these sphere exercises. Both of these examples have the light source coming from the right. This will make all of the shadow areas fall on the opposite side.

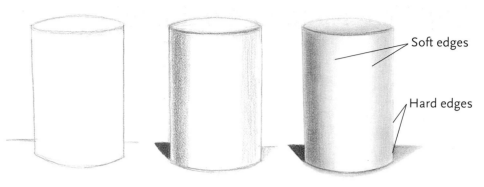

Soft edges

Hard edges

The cylinder is also an important shape. It can be seen in the shape of the neck, the arms and the legs. It will help to practice drawing these simple shapes.

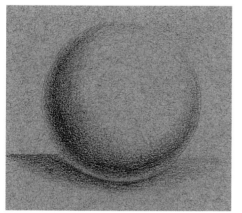

A sphere in a layered technique created by using a Black Verithin pencil.

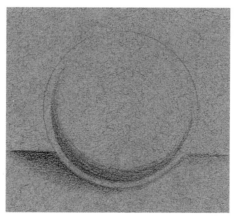

1 Lightly draw a circle with a template. Add a line behind it to represent a tabletop. Draw the cast shadow *beneath* the circle: This helps create the edge of the ball. Start the shading on the ball by placing in the tones for the shadow edge. Be sure to leave an edge for the reflected light.

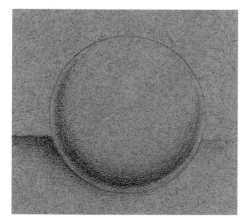

2 Create a gradual transition of tone, going toward the light area. Lighten your pencil touch as you work. Keep your pencil lines curved to create the roundness. This will be your halftone area.

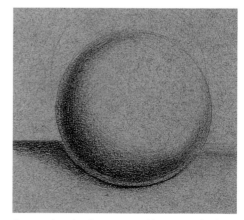

3 Continue developing the halftone area. Remove the visible pencil outline from the light side.

A completed sphere created by using the layered approach.

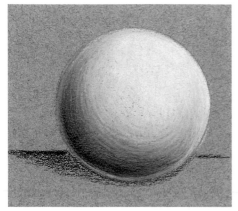

A sphere, using a burnished technique with Prismacolor pencils.

1 Draw the cast shadow beneath the circle with Black Prismacolor. Let it fade to a layered approach as you move away from the ball. With Cool Gray apply the shadow edge, leaving the paper color for the reflected light.

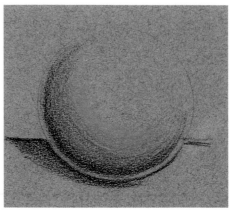

2 With Light Gray, apply the halftone area. Use more pressure this time to cover the paper surface. Apply some of the gray into the reflected-light area. Overlap the darker gray to blend the colors together.

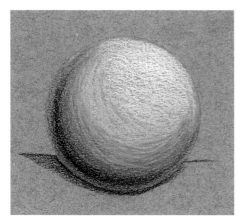

3 Apply White into the full-light area. Overlap the White into the Light Gray. Add some Light Gray into the cast shadow below.

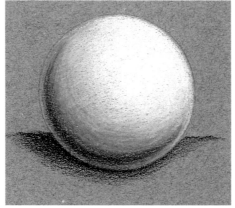

4 Using the light-into-dark method, burnish your colors together until they appear smooth. A completed sphere, using the burnished technique.

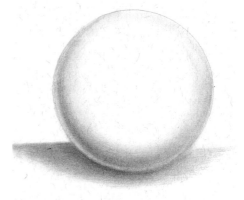

Using a Col-erase or a Studio pencil, try a sphere using the blended approach. This example shows the sphere drawn in violet tones. I used a tortillion to blend the tones together for a gradual blend. Follow the same directions as before for the placement of the tones, but instead of varying the pressure of the pencil, achieve the blend with your tortillion. The nice thing about this technique is the ability to lift your tones with the kneaded eraser if it gets too dark or choppy.

So why is the understanding of the sphere so important when drawing people and faces? Look at the illustration here and you will see. Everything in nature has contours and curves, unless it is an angular, flat structure such as a building or box.

Roundness can be seen in the trunk of a tree (like the cylinder), the shape of an animal and in the human face.

Compare the face of the little girl to the drawing of the sphere. Both have been done using the same light direction, as well as the same colors.

The roundness of the sphere, as well as the five elements of shading, can be clearly seen in the forehead, nose, cheek and chin.

With any of the five elements missing, the realism would be lost and the surfaces would appear flat.

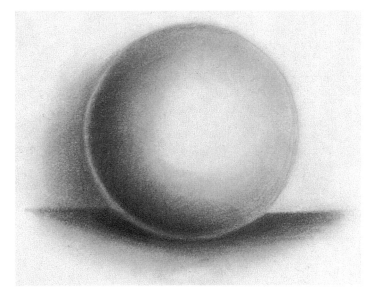

A sphere drawn in Prismacolor in Dark Brown and Tuscan Red on suede board.

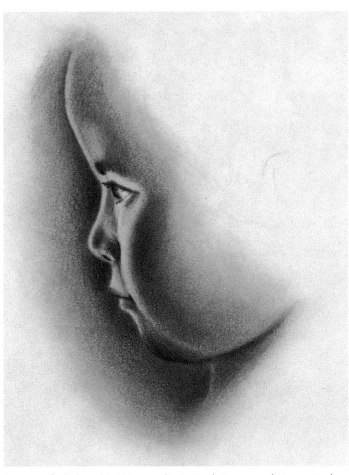

Portrait of a little girl in Prismacolor in Dark Brown and Tuscan Red on suede board.

Colors

When drawing people and portraits in colored pencil, the colors you use will vary from picture to picture. Each one of us has a different complexion and skin tone. But aside from that, color is very reflective and bounces off every surface. Our own skin tones will vary dramatically, depending on the colors of our surroundings and the colors of clothing we are wearing. Lighting is also a key factor that affects how the colors appear in both highlight areas and shadows.

Before you begin a drawing, you must study all of these elements in your picture to fully understand how the colors are reacting and affecting your subject. Although every picture will be different, you will find a certain number of colors being used the most. On this next set of spheres you will see the colors that I use most often when drawing people. You may not use all of them every time, but they make up the most commonly used portrait colors. Use this as your guide.

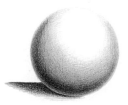

Sphere and skin tone value scale in Verithin: Dark Brown, Tuscan Red, Terra Cotta and Light Peach.

This is a layered technique, which allows the paper to show through. The lightest tone fades into the paper color.

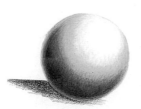

Sphere and skin tone value scale in Prismacolor: Dark Brown, Tuscan Red, Terra Cotta, Peach, Cream and White.

This is a burnished technique, which completely covers the paper surface.

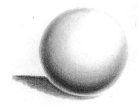

Sphere and skin tone value scale in Col-erase: Brown, Tuscan Red, Terra Cotta and Peach.

This is a blended technique, with the colors blended smooth with a tortillion.

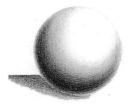

Sphere and skin-tone color scale in Studio pencils, using a blended technique: Ivory Black, Chocolate Brown, Burnt Carmine, Terra Cotta and Flesh Pink.

> **NOTE —**
> The Studio pencil can create all three techniques. Although this example has been blended, you could also burnish and layer. When burnishing, however, since Studio pencils are not as waxy as Prismacolor it may be harder to mix the colors.
>
> Notice how different the colors appear when drawn on toned paper.

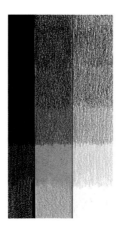

Black, Dark Brown, Tuscan Red, Terra Cotta, Peach and Cream Prismacolor pencils on different paper colors. Select a paper color to help enhance your work.

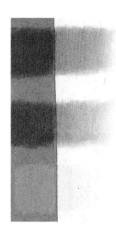

Chocolate Brown, Burnt Carmine and Rose Pink Studio pencils blended on light and dark paper. The colors appear different on each.

When you look at the Prismacolor swatches, notice how I placed the same color on three different colors of paper. Even though it is the same color, it appears different on each one. The dark colors appear lighter on dark paper and vice versa. It is important to select a paper color that will enhance the colors you are working with.

Prismacolor and Studio pencils are two brands of colored pencil that are opaque enough to use on dark paper and still show up. A lighter paper stock will work better with the other pencils. However, a great deal of the subject's color can be achieved with the paper color itself. Resist the urge to draw on white paper all of the time: Experiment with various tints and colors. A Beige, Pink or Ivory colored paper can help you create realistic skin tones.

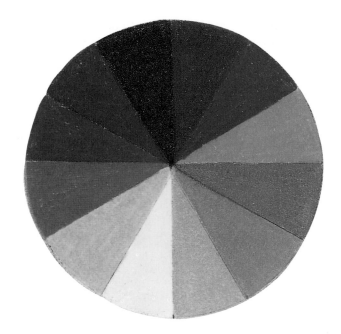

THE COLOR WHEEL
The colors on the left are *warm* colors. The colors on the right are *cool* colors. Skin tones will be made up of each.

NOTE —
When a fixative is used on Col-erase pencils, the pigment melts into a watercolor appearance. The colors will appear much brighter and darker. This can happen also with the Studio pencils, if blended with a tortillion. Leave unsprayed.

ORGANIZING AND USING COLORS

To use colors effectively, it is helpful to understand the color wheel and the way it divides colors into categories. When I draw, and when I teach, I often refer to three terms. Warm colors, cool colors and *complementary,* or opposite, colors.

Warm colors include yellow, yellow-orange, orange, red orange, red and red-violet. A warm color will always seem to come forward in your picture.

Cool colors include yellow-green, green, blue-green, blue, violet and purple. A cool color will always seem to recede in a picture, so they are used in shadow areas.

Colors will help one another stand out, if placed next to each other or used as shading on top of one another. To best enhance a drawing, complementary colors should be used. These can be found opposite one another on the color wheel. Since skin tones often have a reddish or pink coloration, I often will use a greenish or aqua color in the background, so the skin tones will be enhanced. Green will also be used in the shadow areas of a face to help that area recede, yet keep the skin tones fresh. Never use black as a shadow color, unless it is an extremely deep shadow area.

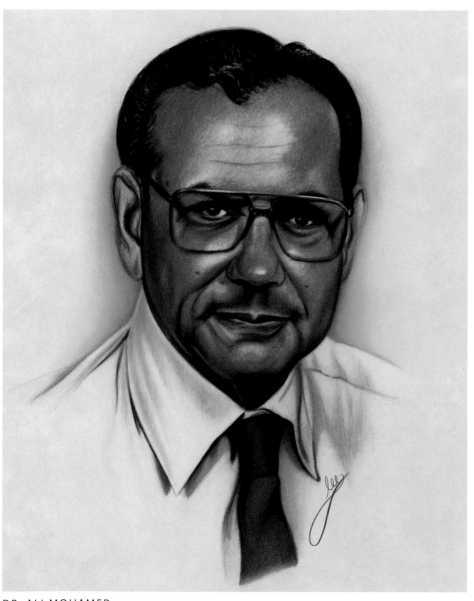

DR. ALI MOHAMED
Prismacolor on no. 7133 Dusty Green suede mat board
16" x 20" (41cm x 51cm)

COLORS USED

Skin tones. For the warm facial features, I used Burnt Sienna, Burnt Ochre and Peach. Dark Umber and Tuscan Red were used for the shadow areas. There is a hint also of Tuscan Red in the lips. I used a no. 1 Negro pencil for his hair, reflecting the Aqua color of the background into it for highlights.

The shirt. The shirt is white, with the Aqua reflecting into it also.

The shadows. Cool gray 50% is used for the shadows.

The tie. His tie is done with Tuscan Red and Black.

Graphing

Drawing Shapes

Of all the aspects of your work, the most important element is the "shape." If your shapes aren't accurate, no amount of technique or color theory will make your drawing look like the person you are rendering. To help my students begin to train their eyes to see shapes properly, I have them use a graph, or grid, method. By placing a graphed overlay on top of their photo reference, the subject being drawn is reduced to simple shapes.

By drawing what I saw in each square, being careful to watch for placement within the box, I was able to achieve an accurate line drawing of the model. Sometimes it is helpful to turn your picture upside down when drawing it. This is a way of seeing it more as just "shapes" and less than as the person you recognize.

For a challenge, and to really isolate the shapes, you could also cut a square out of a piece of paper and cover everything but the box you are drawing. The more graphing you do, the better your eye will be trained to see, and accurately draw, shapes.

USING GRAPHS

The following exercises are designed to help you get used to the graphing process. It will be very important for you to draw the graph lines on your drawing paper very lightly: These lines will need to be erased after the line drawing is completed. If you draw the lines too dark, it will be hard to remove them later. For this reason I use a mechanical pencil for preliminary sketches. These pencils have lighter, more delicate lines than other graphite drawing pencils.

These exercises will be shown again as full-color projects later in the book. As I said, it is more important right now to learn to draw the shapes accurately. Later, I will show you how to apply various types of colored pencil to turn them into realistic portraits.

Let's begin with this photo of my son Christopher. If you look closely, I have combined both one-inch (2cm) and half-inch (1cm) grids for the graph. To achieve more accuracy in the facial features, I divided the one-inch (2cm) squares into half-inch (1cm) squares around the eyes, nose and mouth. Notice how I placed a diagonal line under the eyes? This helps me be sure I get the angle right because of the tilt of the head. The rest of the shapes were easier, so I left them as one inch (2cm).

Also, I enlarged the drawing a bit by making my squares on my drawing paper bigger than that of the photo. As long as your boxes are perfectly square, the shapes are relative. This is a good way to enlarge. It's all about the shapes and their placement within the box. You can reduce a large photo this way, too, by making the square you draw on your paper smaller than the grid over the photo.

Later on, we will be drawing this picture in full color with Verithin pencils. Practice this on inexpensive white drawing paper first and then do it again later on mat board.

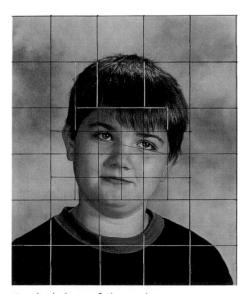

Graphed photo of Christopher

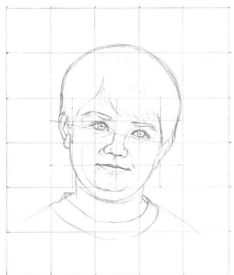

Graphed drawing of Christopher

Graphing Exercises

This photograph will be used for a finished project in Col-erase. For now, practice using a graph, and create a line drawing like the one provided. Remember to draw lightly, and be as accurate as possible.

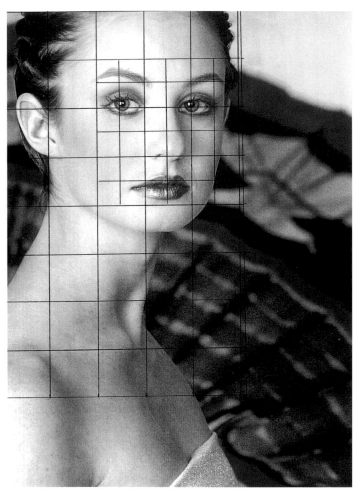

KAYCE
A graphed photo with both 1" (2cm) and ½" (1cm) squares.

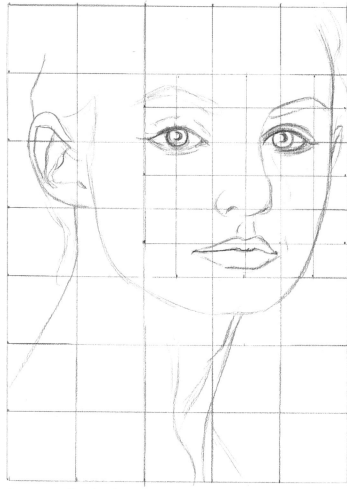

An accurate line drawing.

> **NOTE —**
> This line drawing should be done on Ivory no. 1008 mat board for a step-by-step project later in this book.

This line drawing of LeAnne will be used later for a full-color drawing. Be very careful while obtaining your shapes. The pose and position of this face make the features harder to see and draw accurately.

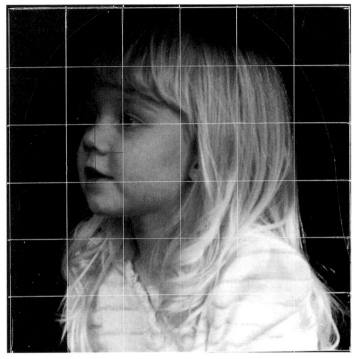

A graphed photo with both 1" (2cm) and ½" (1cm) squares.

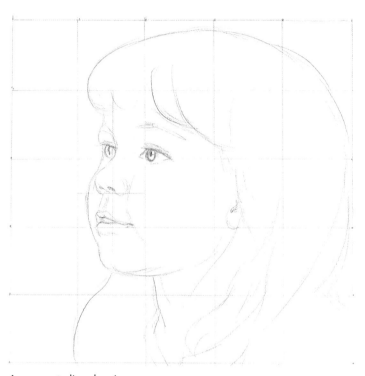

An accurate line drawing.

NOTE —
This line drawing should be done on no. 3301 Heather mat board.

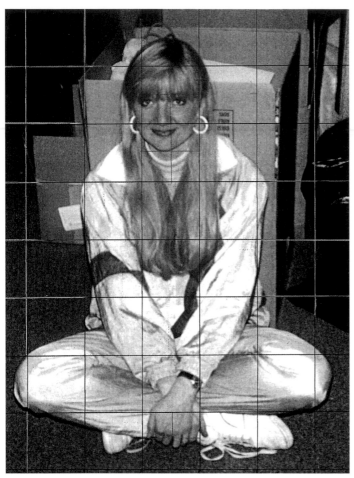

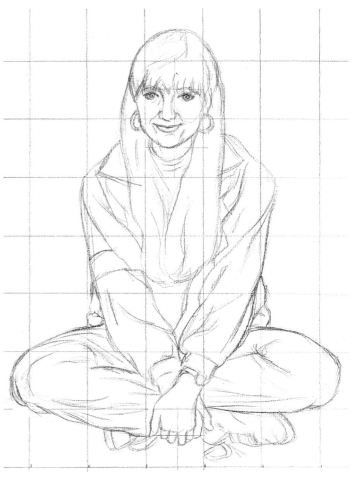

A photograph of a full figure with a graph applied. Practice drawing the whole body with this example. Include the creases and folds of the fabric.

An accurate line drawing.

Drawing the Face and Hands

Drawing the Eye

In the examples, look at how the appearance of an eye can vary. Each example has been drawn with a different technique and has taken on its own special quality. Although they all look quite realistic in the way they were drawn, the different approaches make them all unique.

If you compare the color versions against the gray tones, you can see how much life color can add to a drawing. They seem warmer and happier. The eyes drawn in black and white seem more serious and cold. Below is an eye rendered with watercolor pencils. It has more of a "painted" appearance.

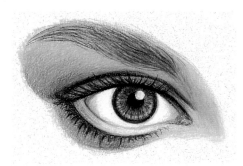

Full-color burnished Prismacolor

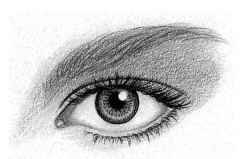

Full-color layered Verithin

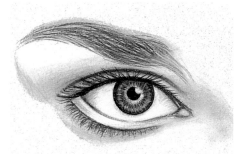

Black-and-white burnished Prismacolor

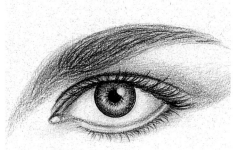

Black-layered Verithin. All drawings drawn on Beachsand Artagain paper

FULL-COLOR EYE IN WATERCOLOR PENCILS
This example, done in watercolor pencils, shows how colored pencil can also look like a painting. This technique will be covered in more detail later.

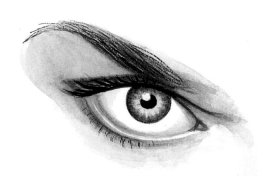

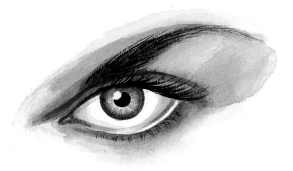

Drawing Eyes Step by Step

It is always easier to learn a technique by practicing in black and white first. This allows you to concentrate on the feel of the pencil and how to apply it without having to switch pencils and colors. It will also give you practice creating "tone," which is the gradual blend from dark to light.

To draw lashes and brows, it is important to have the shapes of the eye drawn accurately first.

The eyebrows should be given some light shading "within" the shape first. The hairs of the brows are then applied on top of the shaded area with quick, tapered strokes. Layer the hair strokes on top of one another to build up the thickness.

Eyelashes are applied with very quick tapered strokes also. The lines originate off of the lash line, along the eyelid. They should not be drawn in single rows, but should be placed in clumps that taper at the ends.

Using the same graphing technique that we used previously, draw an accurate line drawing of these eyes. It will be important to use a template to obtain the perfect circles of the iris and the pupil. Remember this every time you draw eyes: It will make your drawing more realistic. The catch light, or highlight, of the eye should always be placed half in the iris and half in the pupil, no matter how the highlights look in the photo you are working from. If the photo you are working from has more than one highlight in the eye, reduce it to just one. Place the highlights in the same spot in each eye. Remember: The eyes are the most important part of any portrait. It is there that you will find the personality, the mood and the essence of your subject.

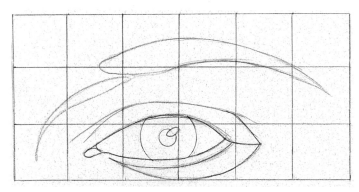

1 Using the graph method and a template for the circles, draw this accurate line drawing of the eye.

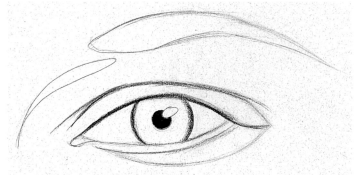

2 With Black Prismacolor, blacken in the pupil. It is *always* centered inside the iris! The catch light is placed one half in the pupil and one half in the iris, regardless of what your photograph may have. Change it if you have to. Darken the lash line and the area around the edge of the iris.

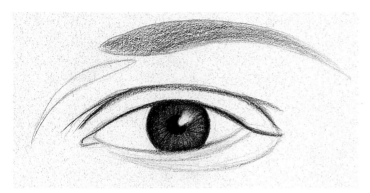

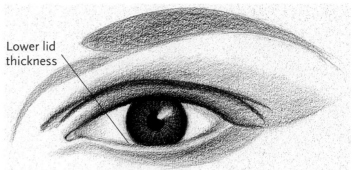

3 Fill the eyebrow area and the iris with Black Verithin. Using a starburst design, create some pattern in the iris. Do not cover up the catch light.

4 Begin placing tone on the eyelid, on the brow bone and below the eye. Look for the lower lid thickness. This makes the eye look three-dimensional and realistic. Begin placing a small amount of shading to the eyeball.

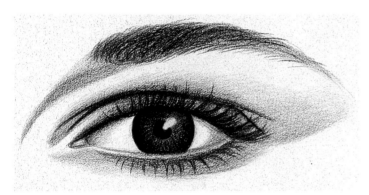

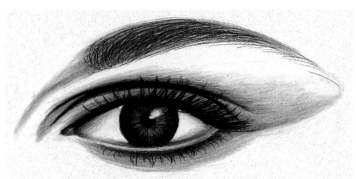

5 Apply the eyebrows and eyelashes using quick strokes with Black Prismacolor. Apply White Prismacolor to the catch light. This drawing could be called finished, if you wanted only the layered technique.

6 To create the burnished look, I applied White Prismacolor over the entire drawing. I reintensified the dark tones with Black and blended the tones together with White again. Can you see how different this makes the eye appear? It takes on a much shinier appearance.

Drawing the Eyes in Pairs

It is important to practice drawing eyes in pairs. These angle lines show you how much the tilt of the face affects the angles of the eyes. Our minds have a tendency to make us draw everything straight across, straightening out everything for us. By giving yourself some guides like this as you draw, you can overcome this common problem.

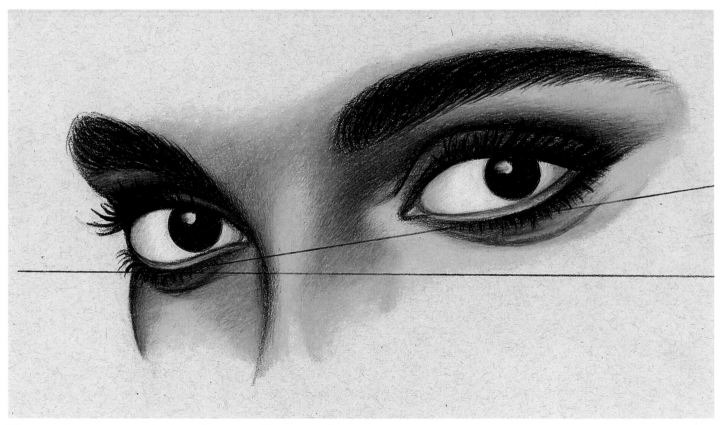

When drawing eyes at an angle, the perfect circles of the irises and pupils turn into ellipses instead (circles in perspective). Templates can be purchased for these.

When drawing two eyes together, a horizontal line can help you see the tilt of the head. The eye on the right in this illustration is almost an entire "eye" higher. These irises are perfect circles. Even though the eyes are turned to the side, the eyeballs are turned to look at you straight on.

Drawing Noses Step by Step

Using the same approach we used for the eyes, begin the practice work for noses. Pay particular attention to the fact that the nose is a rounded form and is gradually protruding from the face. Because of that, you should be careful not to outline the nose as if it were a separate object. The shadow side of the nose does have a hard edge, but be sure to soften it into the face.

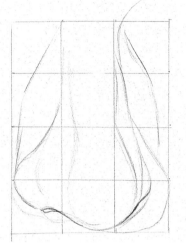

1 Graph a line drawing in pencil.

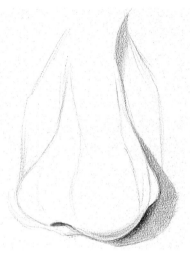

2 When the lines of the graph have been removed, begin placing tone on the shadow side of the nose with a Black Verithin pencil. Try to keep this tone smooth, with no pencil lines showing. Keep your pencil very sharp!

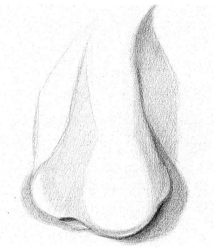

3 Continue adding tone to develop the shape and contour of the nose. Lighten your touch for a gradual transition of tone.

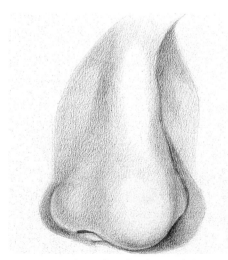

4 Complete the shading of the nose. This nose would be finished at this stage if you are just using the layered approach.

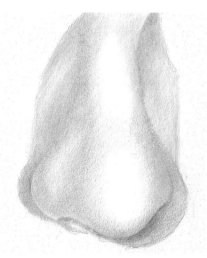

5 To burnish this drawing, apply a layer of White Prismacolor over it. Use firm pressure to cover the paper. It will look a bit "milky" at this stage.

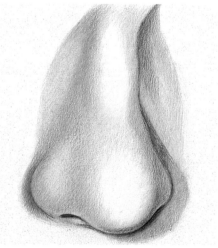

6 Reapply the dark values to the drawing and soften them back in with the White. This drawing now looks entirely different from the previous one.

Drawing a Full-Color Nose Step by Step

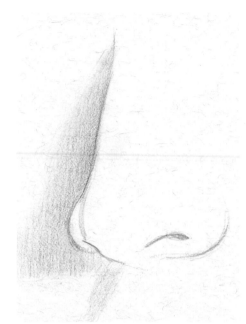

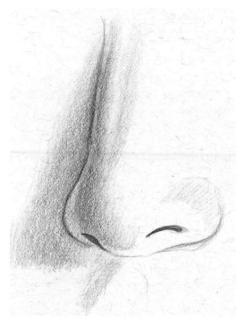

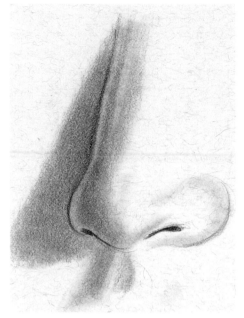

1 To draw the full-color nose in Studio pencils, start with Burnt Carmine for the line drawing. Lightly fill in the shadow on the left with Burnt Carmine also.

2 Place a light layer of Terra Cotta over the Burnt Carmine and onto the skin on the right side. Darken the nostrils with Burnt Carmine.

3 Blend the colors together with a tortillion. The colors will "warm" as they smooth out.

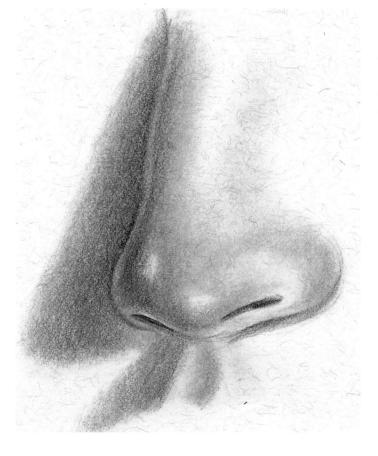

4 I added some Pale Vermilion and Burnt Yellow Ochre for a more golden glow to the skin and blended it in. I used a typewriter eraser to lift the highlights on the tip of the nose.

Drawing the Mouth Step by Step

The mouth is another important feature as far as capturing your subject's personality. It is very important that the mouth be drawn correctly, especially when it is an open mouth smile. Each tooth must be drawn exactly in size, shape and placement in the mouth. After all, if you were to draw me with teeth that looked like someone else's, the drawing wouldn't look like me, would it?

This is where practice plays an important role. When I was learning to draw faces, I spent hours and hours with glamour magazines, drawing every face I could find. It is the repetition that makes us learn the most.

Take the exercises here and practice your techniques.

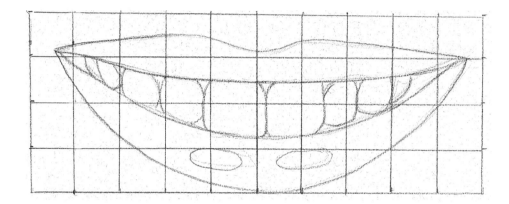

1 A ½" (1cm) graph helped me get the shape of every tooth accurate.

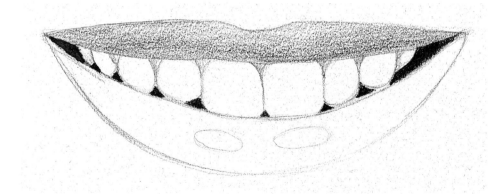

2 The upper lip always appears darker than the bottom one. Begin placing your tones here with a sharp Black Verithin.

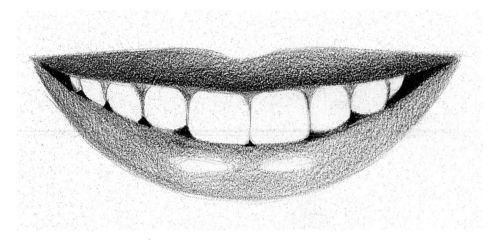

3 Add some tone to the bottom lip. Keep it lighter than the top one. Leave some areas of the paper visible for highlights.

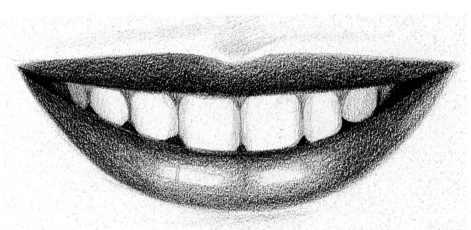

4 Deepen your tones until you achieve the right color. Add a hint of shadowing to the teeth, especially the ones that are farthest back, for realism. Leave the drawing like this if you want to emphasize the layered technique.

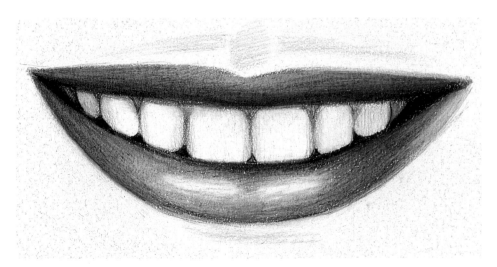

5 For the burnished look, cover the drawing with a coating of White Prismacolor. Reapply the darks and blend again with White until the transition appears smooth and gradual.

Drawing the Nose and Mouth Step by Step

Let's practice drawing the nose and mouth together in the following step-by-step exercise.

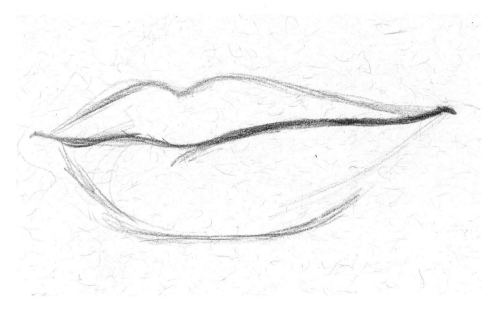

1 For full color with Studio pencils, begin this drawing with Burnt Carmine on the lower lip and Pale Vermilion on the upper lip.

2 Fill in the upper lip with Pale Vermilion and begin applying the shadow area of the lower lip with Burnt Carmine. Add some of the Pale Vermilion to the lower lip here also.

3 Blend your tones with a tortillion. Reapply color and blend until you achieve the tone you want.

4 Add and blend the colors *around* the mouth. Add the nose to complete the drawing.

Drawing Ears Step by Step

The following studies of ears will give you some practice with the Verithin and Prismacolor pencils, using full color. Use a graph to obtain the line drawing. Be careful, because the ear is a grouping of shapes within other shapes: It is easy to get confused.

1 An accurate line drawing on Shell Artagain paper.

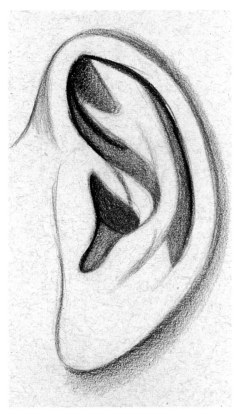

2 Replace graphite lines with a Dark Brown Verithin and begin to apply the shadow areas of the ear. This ear has a shadow behind it, making the edge of the ear appear light. Can you see reflected light around the earlobe? This would not stand out without the dark tone in the background.

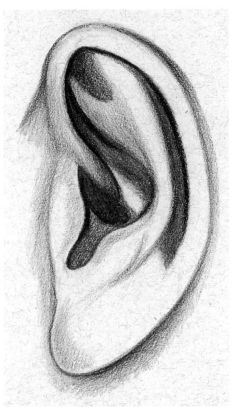

3 Continue adding tone to all of the contours of the ear. Look for where one surface overlaps another, creating "hard edges."

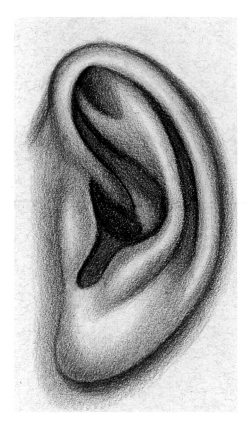

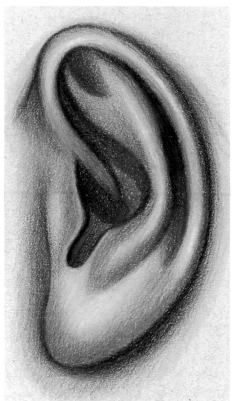

4 Add Terra Cotta Verithin to the drawing. This color will soften the brown into the peachy color of the paper and create the skin tone. This drawing would be complete if you are only doing the layered technique.

5 This drawing was burnished with Light Peach Prismacolor. Using the same colors in Prismacolor as you used before, reapply color and soften it with Light Peach. White Prismacolor has been added for the highlights.

These are common views of the ears as seen in a portrait. As you can see, the hair plays an important part in the way they look. Since most of the time you will not see the ear from a side view, but more from the front, it is necessary to practice all angles and viewpoints. Often, very little of the ear will show, except for its outside edges.

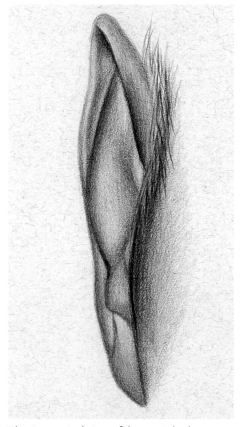

This is a typical view of the ear. It looks very different than the side view we just studied. The head-on view gives you a condensed perspective, with many of the details hidden.

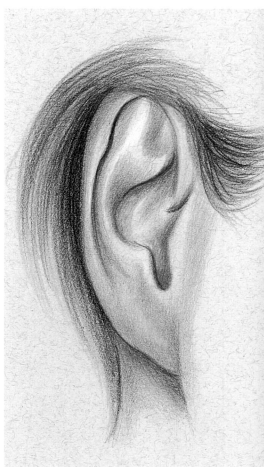

Hair often hides much of the ear.

Drawing Hands Step by Step

Knowing how to draw hands is very important if you are drawing people. However, hands are very complex. To learn them in their entirety, I suggest referring to my book *Draw Real Hands*. For now, I will give you a condensed version of what to look for when drawing them.

Again, shape is crucial to the overall look. Most people draw a hand way too rounded. Instead, look for the many angles and straight edges found on a hand. This graphed example will help you practice. Use a graphite pencil and practice drawing these shapes with a graph.

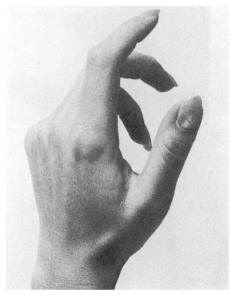

Photograph of a hand.

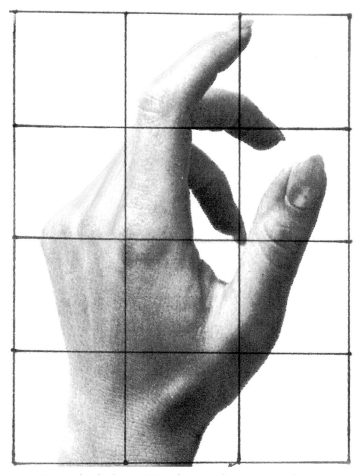

1 A graphed photo. Use this to obtain your shapes.

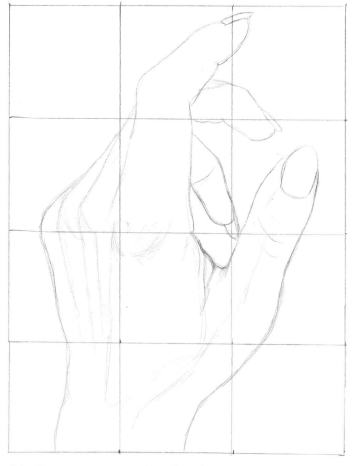

2 Draw an accurate line drawing.

It is not necessary to use a lot of different pencils to achieve realistic skin color. Study the example of the hand drawn only in brown tones. Now compare it to this step-by-step example. By adding a small amount of Terra Cotta to the brown, the final drawing has the look of realistic skin tones.

Hand drawn in brown tones

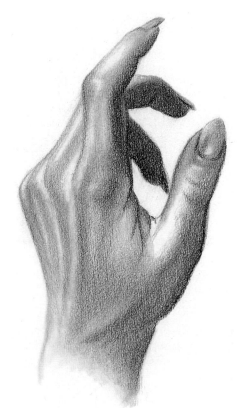

3 Begin adding the shadow areas with Dark Brown. Be sure to keep a sharp point on your pencil to create even tones.

4 Add Terra Cotta to create the midtones of the drawing. Overlap the Dark Brown, which has already been applied. The colors will layer together.

5 Continue adding Terra Cotta until the depth of tone is achieved.

Drawing Hair

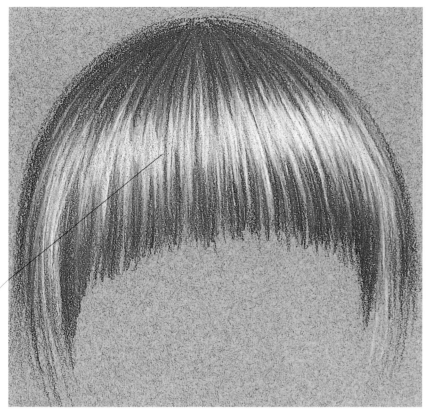

band of light

The band of light is the light reflecting off of the hair where it protrudes the most. It represents roundness.

Drawing hair seems to be a real trouble spot for many artists. There are two things to pay attention to the most. First, look for the direction of the hair and the way it is growing. Second, look at where it is dark because of shadows and where it is light because of highlights. Pencil lines should always be drawn going with the direction of the hair to represent hair strands. A quick stroke will taper the ends of your lines, making them appear more realistic. Hair must also be built up with many pencil layers to mimic the fullness of real hair.

When working with pencils, there are certain colors you can use effectively. The following hair examples will give you an idea of which colors to use. Remember, every picture is different, and this is just a basic formula. You will have to modify it to match the photo reference you are using.

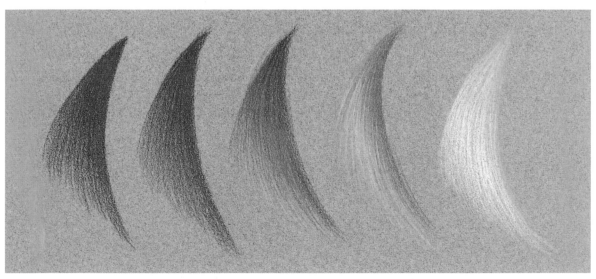

Dark Brown Hair: Black, Burnt Umber and Dark Brown

Medium Brown Hair: Burnt Umber, Dark Brown and Terra Cotta

Light Brown Hair: Dark Brown, Terra Cotta, Goldenrod and Cream

Dark Blonde Hair: Terra Cotta, Goldenrod, Cream and White

Blonde Hair: Goldenrod, Cream and White

Drawing Clothing

These graphite illustrations have been taken from two of my books. I colorized them with Verithin pencils. They are good illustrations to study whenever you are going to draw clothing: Realistic depictions of fabric are essential to good portrait drawing. To fully understand the dynam-ics of drawing the folds, go back to the beginning chapters and study the five elements of shading. All of these elements are seen in clothing and will make your clothing look believable. For more in-depth coverage of clothing, refer to my book *Draw Fashion Models*.

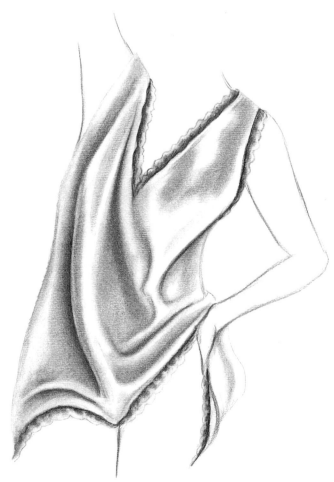

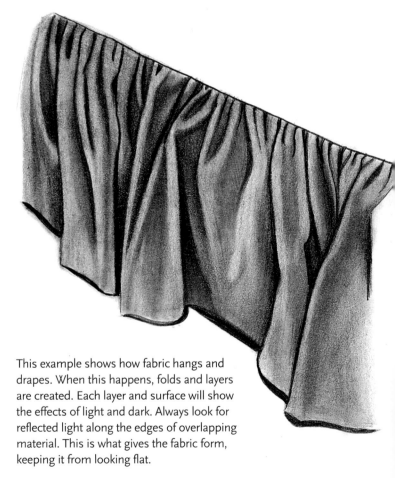

This example shows how fabric hangs and drapes. When this happens, folds and layers are created. Each layer and surface will show the effects of light and dark. Always look for reflected light along the edges of overlapping material. This is what gives the fabric form, keeping it from looking flat.

Look at how the fabric is draping off of this body. To create the smooth look of silky material, I used Col-erase pencils. I used Magenta, with a hint of Gray for the shadows. I blended the color out with a tortillion and lifted highlight areas out with a kneaded eraser. Can you see all of the reflected light along the edges of the fabric creases? Notice how this draping effect is similar to the other examples.

The different colored pencil brands will provide you with a variety of ways to draw fabric and clothing. I already showed you how to create a smooth, shiny fabric with Col-erase pencils. Let's explore what can be done with the others.

As you can see with the stripe of the sweater, patterns are very important.

The seams are what make this drawing look like denim. The areas of light and dark are always seen in denim. The Indigo Blue makes this fabric look very realistic.

Characteristic seams of denim

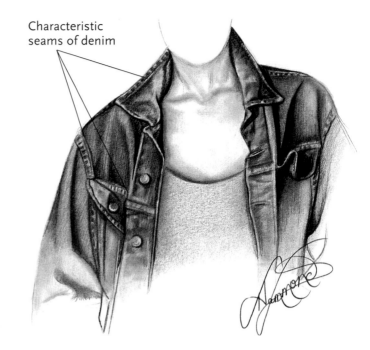

Look for the way fabric creases when stressed or bent. The color tinting helps make the weave of the fabric stand out.

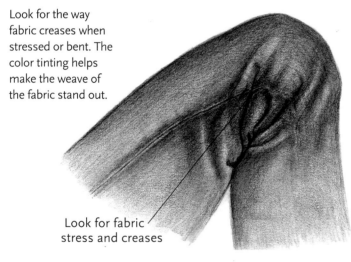

Look for fabric stress and creases

Heavy layering

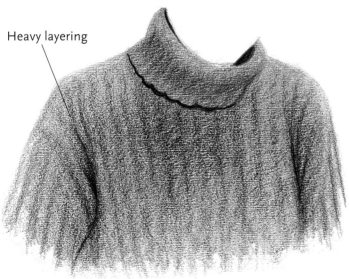

This sweater was done with Prismacolor. To make the fabric seem rough and textured, I used the side of the pencil and a light touch, allowing the texture of the mat board to come through. The heather color was created with Lavender and Cool Gray 50%.

Blended texture

Stripes follow fabric folds

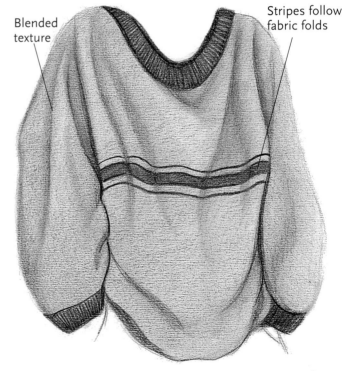

This sweater is much smoother than the other one, but it is still textured: I didn't want it to appear too smooth. To achieve this effect, I used Studio pencils and blended them lightly with a tortillion. The light areas of the sweater were then lifted and softened with a kneaded eraser. I used Light Blue and Gray. Pay particular attention to the way the stripe of the sweater is rolling with the bend of the fabric. This is very important to the realistic representation of the material. Draw the stripe straight across and everything will look flat.

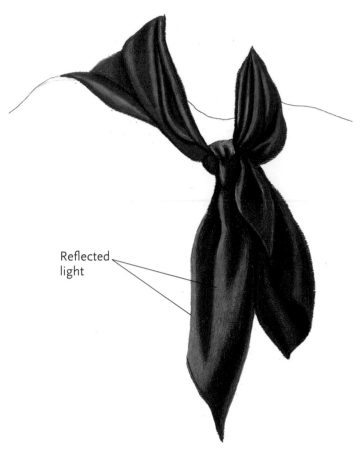

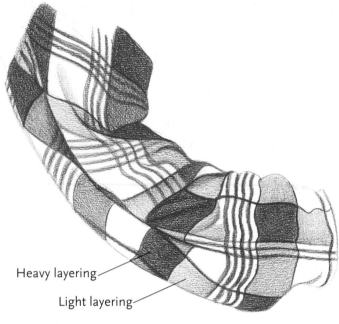

Reflected
light

Heavy layering

Light layering

Plaids can seem a bit overwhelming if you've never done them before. However, if you practice them, they are really nothing more than shapes filled with different tones. When drawing this sleeve, I paid close attention to each individual shape and placed the color in one shape at a time. I made sure that the pattern was bending and rolling with the folds of the sleeve. Some of the shapes had dark blue, while others had a lighter shade of blue. By going one shape at a time, it was easy to follow the pattern. This was drawn with an Indigo Blue Verithin, using a layered application.

You can probably already guess by the dark, smooth color of this scarf that it has been burnished with Prismacolor. It gives the scarf a smooth, opaque quality that only Prismacolor can capture. Look at all of the folds created here. You can see reflected light on each one of them, which makes the fabric appear rounded.

This shirt is drawn with an Indigo Blue Prismacolor, with Cool Gray 50% for the shadow areas and White for the highlight down the back. I used burnishing to make the fabric appear smooth. Again, it is important that stripes follow the contours of the body underneath the clothing. This can also be seen in the next illustration.

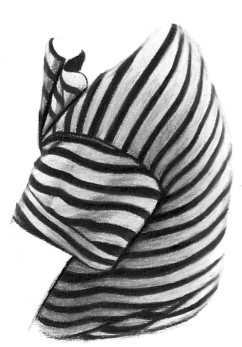

This graphite drawing was tinted with Canary Yellow and Spanish Orange Verithin. It is a good example of stripes following the fabric curves and the form of the human body.

Drawing Clothing Step by Step

To help you practice clothing and drawing them on a real person, let's draw this portrait of Caitlynn.

Begin with the photograph. I've used a white outline to help separate her from the dark background (see the edge of the hat). Create an accurate line drawing using the grid. For this drawing I used no. 1008 Ivory mat board. The final drawing will be done in Studio pencils.

Clothing is an important factor in any portrait. To do it well is essential. Even in a dark outfit, such as this one on the baby, the folds and creases of the fabric can make or break your drawing. Without realistic depiction of this dress, the drawing would not be nearly as cute. Also, the outfit is a large portion of the composition. Without dimension and form, that large dark area would appear flat and compositionally "heavy."

As you draw, look for the creases and folds in the outfit. Look for the hard edges of overlap as you map it out box by box. If you need more help with the shapes of the facial features, you can divide those boxes into ½" (1cm) squares. When you are satisfied with the accuracy of your line drawing, remove the grid lines from your work with a kneaded eraser.

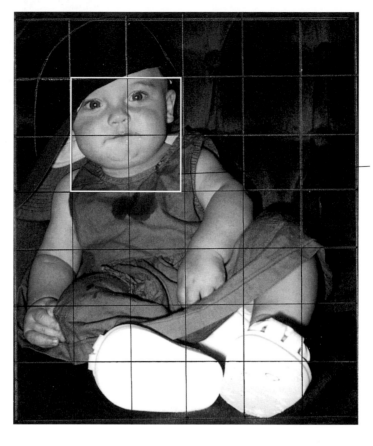

A graphed photo of Caitlynn

Divide these into ½" squares for more accuracy.

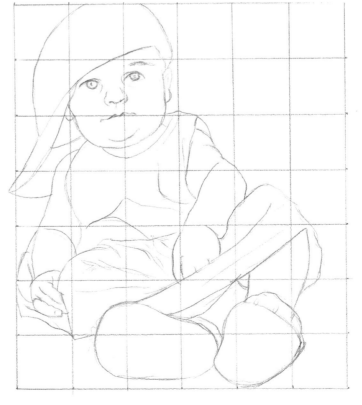

1 Use a graph to achieve an accurate line drawing. Use ½" (1cm) squares in the area of the facial features if necessary.

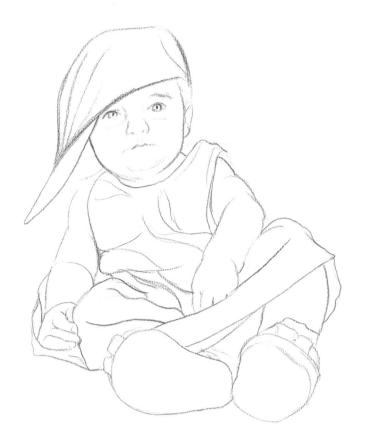

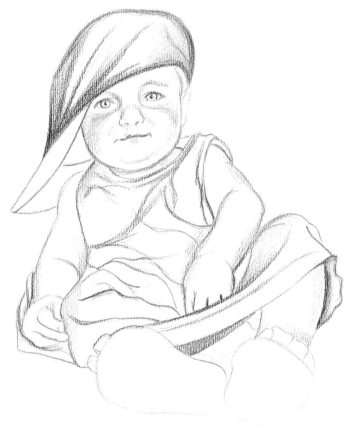

2 When you are satisfied with your line drawing, remove the graph lines from it with a kneaded eraser.

3 Replace the graphite lines with the color that will be used in that area. Use Terra Cotta for the skin and Indigo Blue for the dress and hat. Outline the bill of the hat with Geranium Lake.

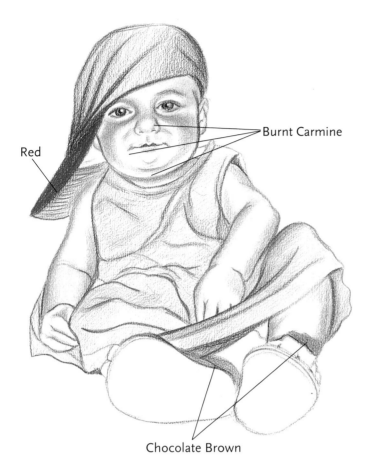

Red

Burnt Carmine

Chocolate Brown

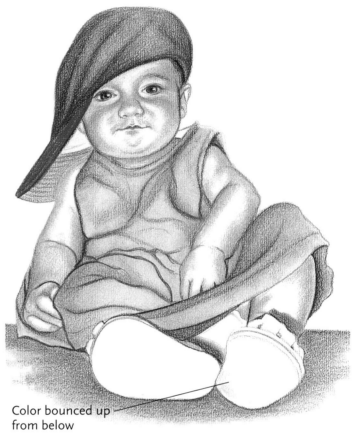

Color bounced up
from below

4 Continue adding more color to the drawing with a sharp point on your pencils.

5 Blend the skin tones, adding some Burnt Carmine for the deeper areas. Fill in the bill of the hat with Geranium Lake, along with Mineral Green for the inside of the bill.

Go to the hat and dress and give it a complete layer of Indigo Blue. Fill in the bill of the hat with Geranium Lake and use Mineral Green for the inside of the bill. To create the shadow above the shoes, use Chocolate Brown.

Gently blend the Terra Cotta color in the arms and legs, allowing the color of the paper to come through for the lightest areas.

To finish the drawing, add more color to the skin tones, using a hint of Geranium Lake for more redness. Everything at this point is blended with the tortillion. Look at how smooth the dress and hat become. If any areas get too dark, or if you need more highlight areas, you can lift light out with a kneaded eraser. Leave the background light, instead of dark like the photograph. However, give her a surface to sit on by using Delft Blue to create a shadow underneath (some of it is bounced up into the bottom of the shoe).

Drawing Portraits With Col-erase Pencils

We are now ready to begin a complete portrait, concentrating on one particular brand of pencil in each of the following chapters. For those of you familiar with my graphite technique, moving to Col-erase pencils may seem like a smoother transition. Much of the same approach is used for both because they both are blended with a tortillion.

Col-erase pencils are clay-based pencils with a very powdery consistency. The colors are not very rich and give a much softer impression when used. Because of this, the Black pencil is very weak and will not produce a deep black. When working with them, I will supplement the black with a "Negro" pencil from Koh-I-Noor. It, too, is a clay-based pencil, but it has a much richer pigment that can produce a deep, dark black tone, without the wax buildup that Prismacolor produces.

This illustration is a good example of what Col-erase can achieve. This monochrome study in Brown and Black has a very smooth look to it. To enhance the brown tones, I chose a mat board with a hint of brown. It is called no. 908 Candle Light.

Study the hair. Can you see how the direction of the hair has been created by the direction of the pencil strokes? Because both the Col-erase

and the Negro pencils are erasable, I used a combination of erasers to lift the highlight areas. A kneaded eraser will produce subtle highlights; a typewriter eraser will create bright light areas.

SAM

Brown Col-erase and no. 1 Negro pencil on no. 908 Candlelight mat board
11" x 14" (28cm x 35cm)

This profile drawing of Jessica Tandy is simple, yet complicated at the same time. The drawing has been "cropped," reducing it to just the face and a bit of the hat. This eliminates unnecessary subject matter that might weigh down the composition. However, the glasses, hat texture and age lines add a hint of an artistic challenge.

I drew this portrait on a paper called Renewal, by Strathmore. Its peach color (called "Shell") really added to the skin tones. I used a Col-erase pencil. Since there is no wax in them to build up the pigment, they are very blendable and smooth out beautifully with a tortillion. They still allow for a hard, defined line, but the colors will not build and become very dark. For deep, dark blacks, I always use a different brand, such as the Negro pencil from Koh-I-Noor.

This is also an example of how I will use opposite, or complementary, colors to add visual impact to a drawing. Because green is the opposite of red on the color wheel, I will often use it as a background color. By placing the green along the edge of the face, the reddish tones of the face are complemented. I then used the same green in her earring to balance the color from side to side.

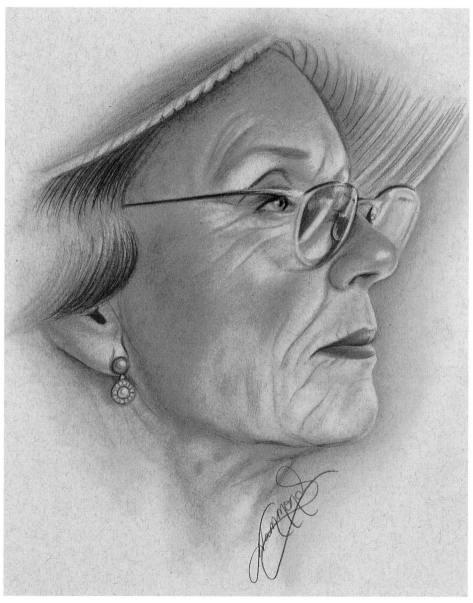

JESSICA TANDY
Col-erase pencils on Shell Artagain paper
11" x 14" (28cm x 35cm)

COLORS USED

Skin tones. I used Terra Cotta for most of the skin, gently blending it into the color of the paper. The jawline and the shadows on the neck were created with Tuscan Red. To increase the color of the cheeks, I blended in some Carmine Red and Vermilion. Her lips are Carmine Red, with Tuscan Red for the crease.

Eyeglasses. To effectively draw eyeglasses, you must see them as patterns of light and dark shapes. The dark areas in the lens on the left are drawn with Brown and Tuscan Red. The outer lens, on the right, has the light green color of the background streaking through. Notice how the light edges of the rims were created by the dark areas surrounding them. It is important not to outline things, but instead to let lights and darks create "edges" for you.

Background. To make something stand out, the use of "opposite colors" on the color wheel is often seen. The opposite of red is green, so I used it in the background to enhance the reddish skin tones. I also used it in the earring to repeat the color on the other side of the drawing.

The hat and hair. Both of these surfaces were done with Brown. Quick strokes were used for both to create the illusion of texture and direction.

Creating Skin Tones

The following illustrations show how versatile Col-erase pencils can be. I began, once again, with just a monochrome study in brown. I used Moonstone Artagain paper. Look closely at how the Brown pencil is blended gently into the color of the paper. See how it fades gradually?

This will help you create smooth skin tones.

The color drawing of the girl has been done on no. 1026 Rose Gray mat board. I tried to keep the drawing simple, not overdetailed. I chose to leave the hair somewhat unfinished for a bit of a graphic look. The suggestion of line gives the hair its direction. Again, notice how smoothly the color has been blended into the paper color. I rendered her skin with the basic skin colors: Brown, Tuscan Red and Terra Cotta. I added Crimson Red into the face for a pinker blush appearance.

PROFILE IN BROWN TONES
Col-erase pencil on Moonstone Artagain paper
11" x 14" (28cm x 35cm)

DRAWING OF A GIRL
Col-erase pencil on no. 1026 Rose Gray mat board
11" x 14" (28cm x 35cm)

Drawing a Full-Color Face Using Col-erase

Now, let's try a full-color example. I chose to use the no. 1008 Ivory mat board for this drawing to help create the subtle tones of the skin. Using the line drawing and the graphed photo example from page 26, let's draw Kayce in full color. When you are working with color, you should replace the graphite lines of your graph drawing with a Brown Col-erase pencil, or draw the graph drawing in Brown to begin with. Sometimes graphite lines can blend into your color pencil and muddy it.

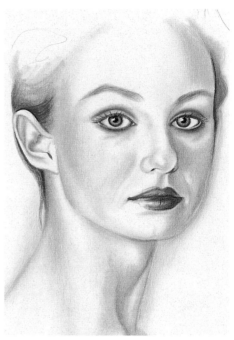

1 Always begin your portraits with the eyes, being sure to capture the circles with a template. Place the pupil in the center of the iris with Black, leaving a small area for the catch light. Later, after you apply more color to the iris, intensify the Black with the Negro pencil. Softly apply some Brown to the eyebrows and blend it smooth. With some Brown, apply color to the eyelid crease. Then place Terra Cotta along the lash line and under the eyes.

2 Continue your drawing by adding color into the face. To develop the shadow areas of the face along the right side, use a light application of Brown and gently blend it with a tortillion. Then add Terra Cotta and blend the two colors together. Add Tuscan Red to the outline of the lips and to the inner membrane of the eyes and below the eyes. Add Tuscan Red to the nostril area.

3 Her eyes are hazel, which is a cross between green and brown. To achieve this color, place Brown around the outside edge of the iris and then add some Canary Yellow and a small amount of Light Green. When blended together, the colors look wonderful!

This face has a beautiful edge of reflected light along the right side. To help describe the edge of the face, start adding the blue background color next to it. Can you see how the reflected light is now visible? Also place Brown into the hairline and behind the ear.

Drawing Portraits With Verithin Pencils

Verithin colored pencils are some of my personal favorites. Sometimes, depending on the subject I am drawing, I want my work to have more of a "drawn" look to it, as opposed to being softly blended. The Verithin line of pencils is perfect for this. Their hard, sharp lead gives my artwork a somewhat grainy appearance.

The Old Masters used to say,

"Draw not just the subject . . . draw the effects of light on the subject." This drawing is a perfect example of this theory. One of my students brought a photo into my studio. I fell in love with it immediately, not just because of the darling little boys. I was entranced by the pose and the color, so I drew it. But most of all, I love the lighting.

Look at the way the light plays off of the faces and hands. It gives the illusion of warm sunshine radiating in through a window. The "band of light" along the head of the boy on the left makes his hair look so soft and shiny. I added some Prismacolor White to the highlight areas to make them stand out.

The Verithin pencils allowed me to control the effects of light on the clothing by using layers of color as opposed to adding light. The light areas are just layered more lightly to allow the color of the paper to come through: No white was added. For the shadow areas in the clothing, I used Tuscan Red. The brown background color behind the subjects helps define the outside edges, allowing the reflected light to be seen.

Whenever you are researching photos to draw from, this type of lighting situation will produce the best looking artwork.

I use Verithin for a variety of looks. I usually reserve the blended techniques for light portrait work, such as babies and women. I use Prismacolor for bright colors and shiny surfaces. I find Verithin good when drawing situation poses, textures and rougher skin tones on porous surfaces.

ROB AND BEN
Verithin on no. 1008
Ivory mat board
16" x 20"
(41cm x 51cm)

On this piece, the matting around it is as important as the artwork itself. Always enhance your work, compositionally and with the color scheme, when selecting your mats and frames. Be as creative with this as you are with your art.

Drawing a Full-Color Portrait Step by Step

A full-color portrait is a challenge. Let's draw Christopher together. Refer back to the line drawing we did on page 25 and follow along, step by step. This portrait was done on no. 1008 Ivory mat board. The line drawing is done with Verithin Dark Brown.

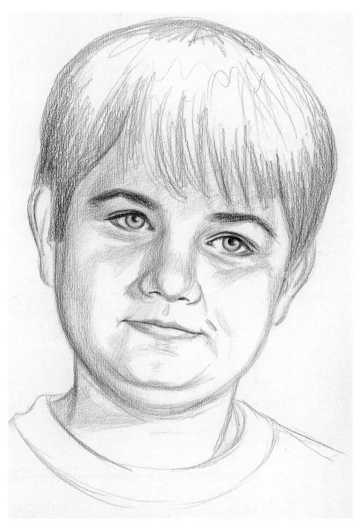

1 Start the portrait by adding a touch of Black into the eye area. Gently apply some Black to the eyebrows and the lash line. Draw in the irises and pupils of the eyes with a template, leaving a spot for the catch light. Also take the Brown down the side of the nose to develop the shadow there.

2 Continue to apply some tone to the hair with quick, sharp strokes of Dark Brown. He has two bands of light, so be careful not to fill it all in. For his skin tones, add a touch of Terra Cotta to the face and lips.

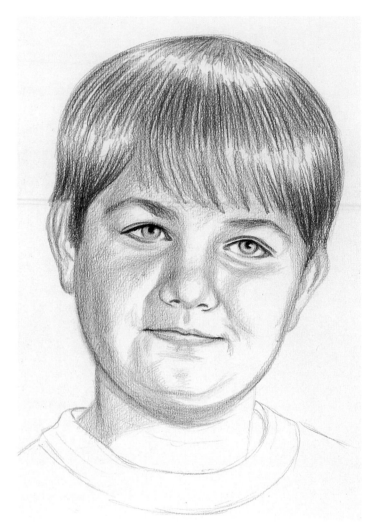

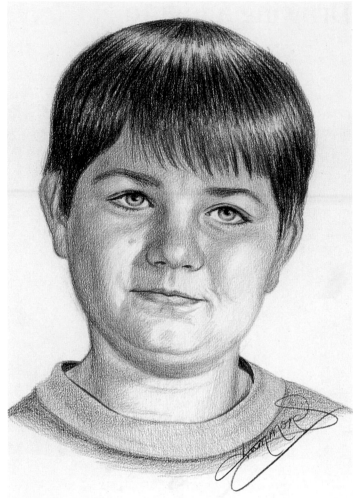

3 Add more Dark Brown to the hair to help it fill in. Remember, the hair is made up of many, many layers of tone, building up the thickness that it represents.

Continue developing the shadows of the facial contours with more Brown and Terra Cotta. Also add a touch of Indigo Blue to the iris of the eye.

4 As you can see, the finished drawing is much deeper in tone. By applying Black, you are able to darken the eyes and deepen the hair color. To make the highlight areas of the hair appear more natural, use a kneaded eraser to lighten and soften the edges.

Also deepen the skin tones with more Terra Cotta and a touch of Light Peach to help them fade into the paper color. Use Tuscan Red in the shadow areas along the side of the face and under the chin.

To complete the drawing, use Black and Dark Brown with a very light touch to create the neckline of the shirt. It is hard to believe that such a realistic-looking drawing can be created with just a handful of colors.

Drawing a Figure

Next, let's do a figure drawing from the line drawing on page 28. This project will give you practice drawing the entire figure. Look at everything as independent shapes within the grid boxes as you draw the picture accurately with your graph. Pay particular attention to the creases and folds of the clothing. These represent the body underneath and the stress placed on the fabric by the body's position. For this drawing, I used the Verithin pencils on Ivory no. 1008 mat board.

When you draw the face, refer to the previous exercises for information on the features. It will be harder to draw the face accurately when drawing small, so keep a sharp point on your pencil to keep the lines thin and easier to manage in small areas. It will also help you to draw lightly at first, so you can alter and correct the features as you work. When you feel you have achieved a good likeness, then you can build up the color.

Photo of the author

1 Once your graph lines have been removed, begin to replace them with your Verithin pencils. Use Dark Brown for the face and hair. Use Rose for the clothing. Keep the pencil lines light at this stage.

2 Build up the color of the hair with Dark Brown. Look at the photo for the patterns of dark and light. Apply the pencil lines with quick strokes, following the direction of the hair.

Finish replacing the graphite lines of the clothing with the Rose color. Lightly fill in the stripes of the jacket.

Begin to add some color to the face and hands, starting with the outside edges. Use Tuscan Red for the dark edges and then fade in from that with Terra Cotta. Tuscan Red was used for the lips. Black was added to the eyes for definition.

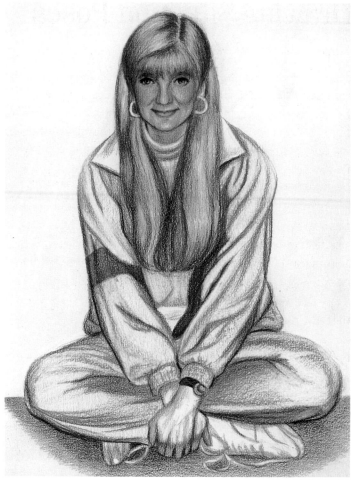

3 Continue building the color of the hair. Add some Terra Cotta to the brown for more of a reddish cast, as well as Golden Brown for a blonde look. Again, put in the pencil lines following the direction of the hair.

Continue adding color to the outfit. For the stripes, use Process Red. Also place the red in the creases for more darkness. Under the elbow, place some Parma Violet (lavender). This creates the look of a shadow.

Add some of the Process Red to the face so that the color of the outfit will reflect into the skin tones.

Add some Tuscan Red into the knuckle area of the hands and between the fingers. For the front of the hand, add a small amount of Terra Cotta for the skin tone.

4 To finish the hair, soften it by gently rubbing over it with a typewriter eraser. Add some highlights the same way. Look closely at the bangs. Lift a band of light for roundness.

Finish the clothing by filling in the fabric area with Deco Pink. Then lift the light areas out with a typewriter eraser. This gives the fabric the folds.

Add some of the Deco Pink into the face to complete the skin tone. To make the eyes stand out more, add White Prismacolor to the white of the eye.

Finish the hand by making the knuckle area darker with Tuscan Red and Terra Cotta. Draw the watch in Dark Brown without much detail.

Finish the shoes with Lavender and Cool Gray 50%. Again, don't add too much detail; add just enough to create the illusion of shoes.

Finish off the drawing by adding the shadow underneath. For this, use Cool Gray 50% and Terra Cotta layered on top of one another. Adding this makes the drawing appear more solid. The shadow helps define the shape of the shoes and gives the impression of a floor underneath the figure.

Drawing Situation Poses

Both of these drawings are more complex than what we have covered so far. They are situation poses, or character studies. They do more than just tell us what someone looks like, as in a posed portrait. They tell us what they are doing.

The wedding picture of my nephew is an excellent example of a situation pose. This is why they call it "illustration." It is designed to tell a story about the subjects. The layered approach with the Verithin pencils allowed me to capture the texture of the suit and the wedding veil, but applied lightly, I was still able to make their skin look smooth.

Music on the Wharf is a great reason why I always have a camera ready. It is a wonderful example of a character study. This is another one of my favorite drawings because of the story it has to tell. I think the Verithin pencils captured the various textures of the drawing wonderfully. Look at the texture of his jeans. You can see the illusion of the fabric weave in the highlighted areas. The sun is shining off of the surface of his jacket, making it look smooth and leather-like. The texture of his hair was created with the side of the pencil and tight circular strokes.

I deliberately kept the background simple so it wouldn't take your attention off of the main subject. With a touch of Indigo Blue horizontal lines, I was able to create the illusion of water. With some Brown and Black diagonal lines, I created the look of a wooden dock underneath him.

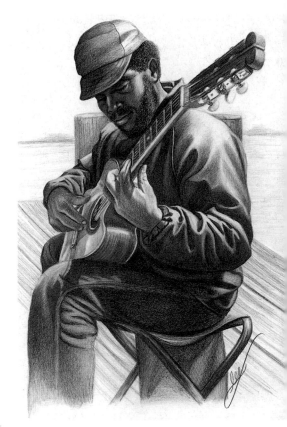

MUSIC ON THE WHARF
Verithin on Strathmore Renewal paper
11" x 14" (28cm x 35cm)

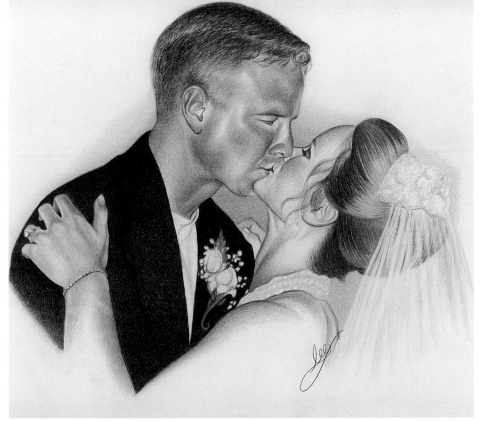

COLORS USED

Skin. Terra Cotta, Dark Brown and Tuscan Red
Jacket. Black, Indigo and Dark Green
Jeans. Indigo, Black and Peacock Blue
Water. Indigo Blue

BILL AND CHRISTINA
Verithin on no. 1008 Ivory mat board
16" x 20" (41cm x 51cm)

Drawing Portraits With Prismacolor Pencils

When you want to make a bold statement of color with your work, Prismacolor is the way to go. Its waxy consistency and brilliant color range can give your drawings the look of oil paintings.

The drawing of the clown shows you just how bright the colors are. The creaminess into which they blend on the paper makes them quite easy to use for brightly colored subject matter. They are also excellent for creating bright highlights and sheen. Whenever I see shiny surfaces, I reach for my box of Prismacolor pencils.

When using Prismacolor, you can employ a variety of applications and techniques. To get the bright hues seen in this clown, I used burnishing. *Burnishing* is a process of building of thick layers of color. It can be quite time consuming, so be patient. All of the colors must be heavily applied to completely cover the paper's surface. Then every color added must be softly blended into the others. Generally,

you will always use the lighter colors to blend in the darker ones. There is no limit to the number of colors you can add. It is a back and forth process of adding and blending until you have achieved the look you want.

But, burnishing is not the only technique that can be used with Prisma-

color. Look at the hair of the clown. This fuzzy texture was created using the side of the pencil with tight, circular strokes. I layered various colors together to give it contrasts of both light and dark. Can you see how each color blends into the next one?

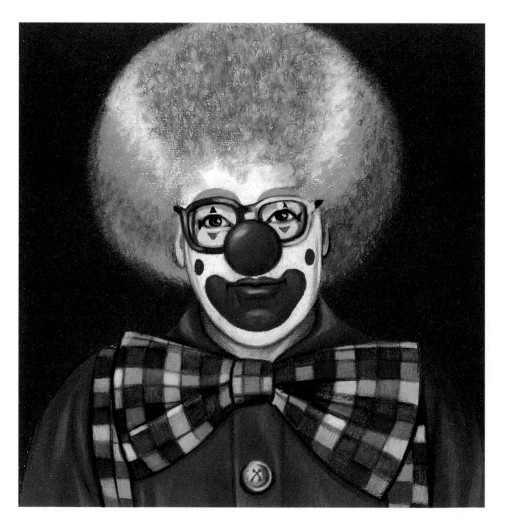

Prismacolor is good for very bright subject matter. It will completely cover the paper surface. Textures, such as this hair, can be achieved with the side of the pencil and a lighter touch.

THE CLOWN
Prismacolor on White illustration board
9'' x 12'' (23cm x 30cm)

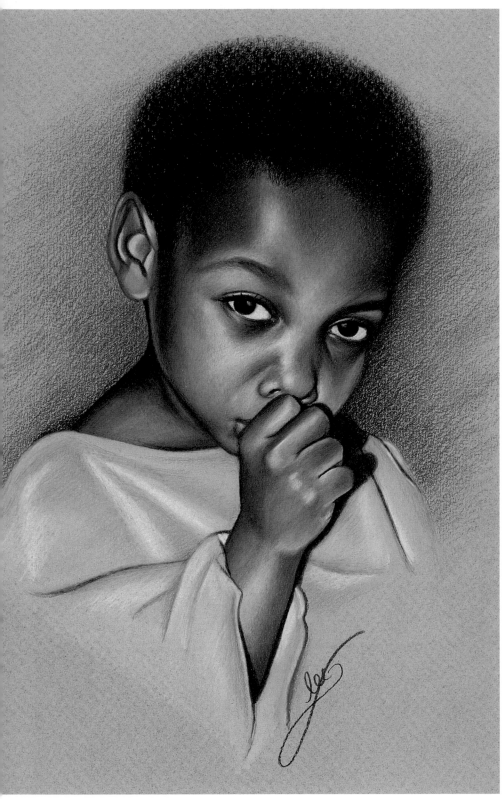

COLORS USED

Skin tones. White, Cream, Peach, Deco Yellow, Terra Cotta, Mahogany, Dark Brown, Tuscan Red and Black. I started with the Peach, laying down an even coating of color, and then started working the dark shadow areas into it. Those colors are then softened together using the Peach. The lighter areas are built up slowly, gently softening them into one another. Many layers were used, going back and forth, until the right color was achieved. It is very important to have both the shadows and the highlights placed accurately to help create shape.

Eyes. Dark Brown for the iris; Black for the pupil. White for the sclera and catch light. Black was used for the eyelashes; Dark Brown was used for the eyebrows. Always be sure to have the skin tones applied first, and then place the eyebrows and eyelashes on top of them.

Hair. Dark Brown and Black, using the side of the pencil for texture.

Clothing. True Blue combined with White. Cool Gray 90% was used for the creases and the shadow of the hand. Peacock Blue was used on the edges of the creases and shadows to soften them and make them appear less hard-edged.

Background. Indigo Blue, combined with Cool Gray 90%, and softened on the outside edges with Peacock Blue. I used a light touch to create texture.

LITTLE BOY SUCKING HIS THUMB
Prismacolor on no. 3305 English Stone mat board
16'' X 20'' (41cm X 51cm)

Refer back to the line drawing we practiced of LeAnne on page 27. For this portrait I used no. 3301 Heather mat board. It isn't necessary to use this exact color, since we will be using Prismacolor and the burnished technique. I used it more for its look as a background color. You can use any light color to draw this on.

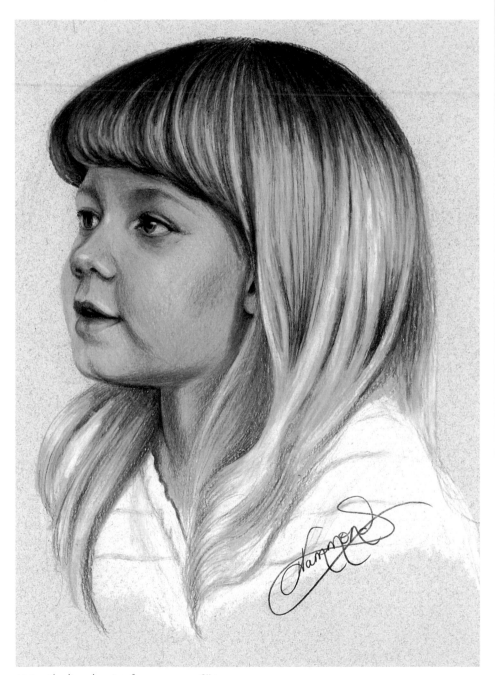

Using the line drawing from page 27, fill in the entire face area with Light Flesh Prismacolor. Terra Cotta can then be used to define the facial features.

A PORTRAIT OF ANNIE
Prismacolor on no. 3301 Heather mat board
9'' x 6'' (23cm x 15cm)

COLORS USED

Face: I applied the pupil with Black, adding a small amount to the lash line as well. I then added Cool Gray 50% to the iris and added White to the sclera of the eye, streaking some of it into a highlight across the iris into the pupil. This makes the eye look shiny. Inside the mouth I used Dark Brown to make it look dark without using black. I began to place a bit of Terra Cotta under the eyes and into the upper lip.

Hair. With Dark Brown and Terra Cotta, I began the process of layering the hair. Notice the directions of the pencil lines and how they represent the hair strands. I made sure to leave room for the "band of light."

Hair and skin tones. In this stage I began to increase the skin tones with more Terra Cotta. I added some Pink into the cheek area and jawline as well. I then went back up to the hair, darkening it with more Dark Brown and Terra Cotta. To make the hair appear brighter, I added some Yellow Ochre to the lighter areas.

To finish the hair. I burnished it with Cream and White. I then added more color with the Terra Cotta and Yellow Ochre and burnished once again. I reapplied some Dark Brown and burnished it in.

Clothing. The clothing is just plain White, enhanced with a touch of Lavender.

Finishing the portrait. To finish the portrait, I had to burnish all of the colors together. To do this, I went back to the Light Flesh that I started with. I softened in all of the colors and reapplied some Pink and Salmon Pink to warm up the skin tones. Remember, you can go back and forth as many times as necessary to achieve the color and smooth blend you desire.

Combining Pencils to Get the Look You Want

I mentioned before how sometimes it is necessary to use a combination of pencils to achieve the look you want. These two drawings are examples of that.

The drawing of LeAnne and Christopher reading is also a combination of Verithin pencils combined with Prismacolor. If you look closely at the textures and color of this drawing, you can see where each pencil has been used. As with many of my colored pencil drawings, I use Verithin to depict the skin tones and Prismacolor to render the bright colors of the clothing.

COLORS USED

Skin. Verithin Dark Brown, Tuscan Red and Terra Cotta
Background. Verithin Indigo
Hair. Verithin Dark Brown, Yellow Ochre, Terra Cotta and White
Clothing. Christopher: Prismacolor Ultramarine and Indigo Blue
LeAnne: Prismacolor White, Blue Slate and Cool Gray 50%

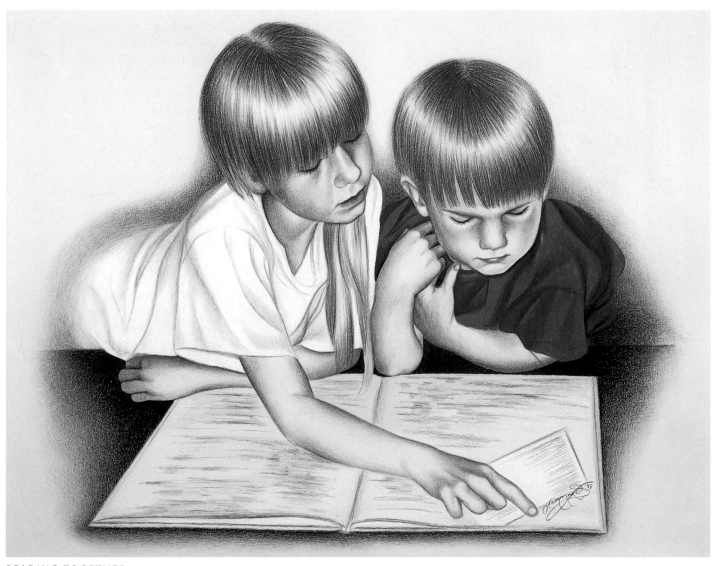

READING TOGETHER
Verithin and Prismacolor on no. 1030 Pastel Pink mat board
16" x 20" (41cm x 51cm)

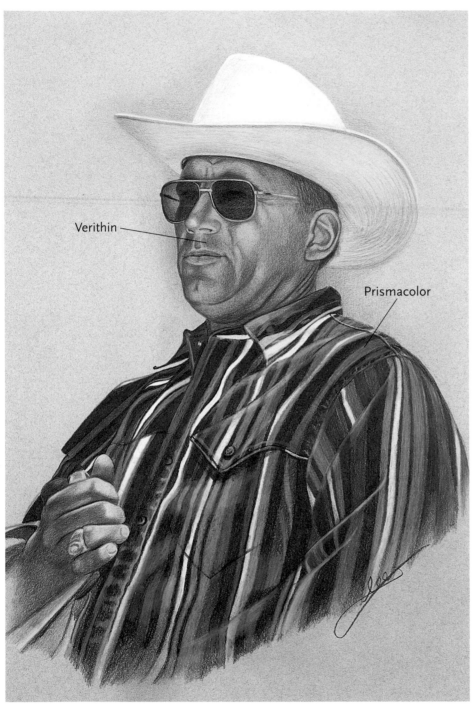

Verithin

Prismacolor

The drawing of my brother is a combination of Prismacolor and Verithin pencils. Because his face is textured, I used the Verithins to create his skin tones. I thought Prismacolor might make his face and hand seem too waxy looking. I also used Verithin for the color in his sunglasses so they would appear transparent, allowing the color of the paper to shine through.

BILL AT WICKENBURG
Verithin and Prismacolor on
Storm Blue Artagain paper
19" x 24" (48cm x 61cm)

Drawing on Velour

As an artist, I am constantly trying new things. Where other famous artists have excelled at one medium or technique, becoming well known for that particular look, I decided early on that I couldn't be that way. I'm too curious, and my art takes me all over the creative map.

Just when I thought I had tried about every drawing technique out there, I happened to stumble onto this new technique, purely by accident. It is wonderful and is perfect for the drawing style that I have. It takes Prismacolor and makes it look soft, like pastel. I am anxious to share this discovery with you!

This is my first portrait using this technique. It begins with a sheet of velour paper. Velour paper itself is not new. It has been around for decades as a support for pastel artists. I carry it in my studio for just that purpose. It has a fuzzy, flocked surface that makes the pastel pigment fan out and appear softly blended.

One of the problems with that technique, however, is acquiring crisp, fine lines with pastel. Even a pastel in pencil form has a rather large tip to it. After experimenting, I found out that the waxy lead of Prismacolor took quite well to this paper, and I used it to sharpen the lines and edges of my pastel drawings. Curiosity then led me to see what Prismacolor could do alone if used on this fuzzy surface. I was hooked! It is a beautiful technique and has become one of my favorite and most used mediums. I have found it to work just as well with other subject matter, too. (Hmmm, do I feel another book coming on?)

I love the contrasts in this drawing. The skin tones are so smooth and realistic looking. I also like the background colors. By using the blue tones, I gave it an airy, outdoor feel. For this I used three shades of blue: True Blue, Light Aqua and Periwinkle. They contrast sharply against the dark tones of the sunglasses and hair color and gently enhance the color of his skin.

SAM MOHAMED
Prismacolor on Gray velour paper
11'' x 14'' (28cm x 35cm)

COLORS USED

Skin tones. To get the skin tones, I started with Peach as the base, gently fading it into the paper color. The Velour keeps the Prismacolor from building up and getting waxy, so the burnished approach is not used here. A smooth, even application is all you need. It is a gradual blend, with light pressure applied to the pencil. I used Tuscan Red for the jawline and Dark Brown for the five o'clock shadow. I used Henna to create the pigment of the lips, as well as the deeper skin tones on the shoulder and chest. On the back of the neck, I used Light Umber.

Teeth. If you look closely at the teeth, they are the color of the paper. Making the teeth bright white is a common mistake made by students. They aren't bright white. Notice that by adding a few White highlights to the teeth, they look very natural and realistic. If I had made them all white, they would have looked fake.

The sunglasses. The sunglasses were built up with Dark Brown and with Black for the deeper areas. If you look closely, you will see other colors, such as Light Blue, Violet and some of the skin tones reflecting off of them. The dark "shapes" create the illusion of an eye back there, without showing any details. The addition of the white glare streaking across them makes them look shiny.

Hair. The hair was created with many pencil lines, all following the hair's direction. It is important to keep that pencil point sharp and to use quick, tapered lines when doing hair. Look at the ends of the hair and see how thin the lines become. I layered Dark Brown and Black, leaving the highlight area a bit lighter. I also used my typewriter eraser to streak the highlights even more.

Drawing on Suede Paper

I think suede paper gives portrait drawing such a beautiful look. Like the other colored pencil techniques we have covered, it is important to choose a paper color that will help create the colors of the skin. This drawing has been done on no. 7132 Whisper.

As in the previous examples, look at how smooth the skin tones appear. The light application and even pressure of the pencil are crucial for this gradual blending of colors. However, firm pressure can also be applied for dark, crisp lines and edges. For example, look at the jewelry, as well as the eyelashes and brows. These lines are very precise.

The smoothness of the suede mat board gives the illustration its beautiful look. The soft nap of the board takes the pigment of the pencils and softens it to create the subtle look of a pastel drawing. While Prismacolor is often used to create bold, smooth color, the suede board softens the colors, allowing the pencils to be used in a whole new way.

COLORS USED

Skin tones. I used Peach for the basic skin color, allowing the paper to come through. For the darker areas I used Henna, Terra Cotta, Burnt Ochre, Tuscan Red and Light Umber. I also used a small amount of Yellow Ochre to give the skin a warm glow in areas. Cream and White were used for highlight areas. However, very light colors can look flaky when applied lightly on this paper. That is why I use a light paper to help create the highlight areas: It looks more natural this way. But when burnished with firm pressure, the white of the dress really stands out. For the lips, I used Mahogany Red for the base, Tuscan Red for the crease and White for the highlight.

Hair. Often, when trying to create deep, smooth black areas, I switch to the Negro pencil. It does not have the wax content to it and gives off a much richer pigment. For this hair, which is very deep in tone, I used a no. 1 Negro pencil. The highlight areas of the hair were streaked in using Light Aqua Prismacolor.

Background. Behind the face, I started with Blue Violet Lake and then transitioned it into Light Aqua and Deco Blue.

Jewelry. For the beads of the necklace, I used a very sharp no. 3 Negro pencil. To give it a hint of color, I applied some Parrot Green and then added White for highlights.

The gold jewelry was created with Yellow Ochre and Mahogany Red with White for highlights. The pearls on the headpiece were created with a sharp White to contrast against the hair. The red ornaments were done with Mahogany Red and Tuscan Red.

Clothing. The greens were created with True Green as the base color and Olive Green for the darker areas. A bit of White was added for highlights. The white area was done with firm pressure on the White pencil. Yellow Ochre was added for the detail. I added a bit of Scarlet Red for interest. To soften the edges where it fades into the paper, I used Deco Blue.

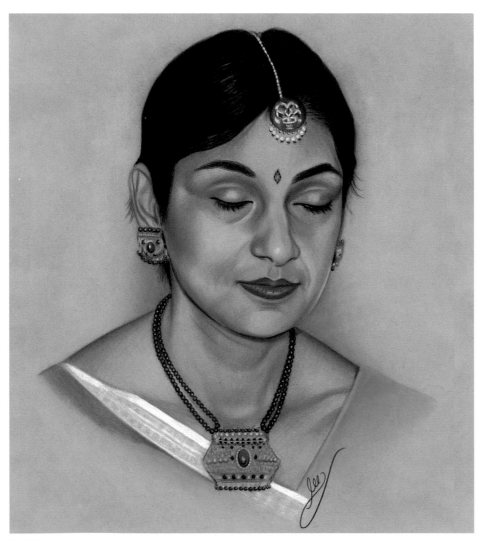

SONIA
Prismacolor on no. 7132 Whisper suede mat board 11" x 14" (28cm x 35cm)

When using this approach, you do not need to push hard on the pencil. Instead, an even layer of light pressure helps the pigment go on smoothly and evenly. The colors gently transition without creating hard edges. With this technique, it is important to pick a paper color that will help create the colors of the skin, since the paper color shows through. I have found this to be one of my favorite techniques for creating realism.

Although a light approach is used for the soft, even skin tones, you can still use pressure and a sharp point to create hard edges. Look at the depth of tone achieved this way in both the hair and the jewelry. You can also see this precision in the eyelashes and eyebrows.

This paper is excellent for all skin tones and colors. This portrait of my children's grandmother is very light and delicate. I used the same paper as I did for the Indian woman (no. 7132 Whisper) and many of the same colors for the face. I just used less for this drawing, allowing more of the paper color to come through. You can see how different it looks. I added some of the Aqua and Lavender into the face to make it more realistic. Remember, colors bounce around and reflect.

Here is just a note about drawing eyeglasses. Study how the coloration of the frames changes from area to area. Never just outline the rims. Study the effects of light and shadow. Also, glasses cause shadows on the face. By including them, the portrait will look more realistic. These particular glasses are not clear: They have a touch of color to them. Can you see how the skin color seems a little bit darker behind them?

IN MEMORY OF RUTH HAMMOND
Prismacolor on no. 7132 Whisper suede mat board
16'' x 20'' (41cm x 51cm)

Drawing Portraits With Derwent Studio Pencils

By now, you have figured out that what I say is true for colored pencil: Every brand has its own qualities and features that help to create different looks. The Studio line of pencils by Derwent is a completely different type of pencil.

These pencils are clay-based. They also come in an "Artists" line, which is the same formulation but with a bigger diameter lead. Since I like a sharper point, I use the Studio line the most.

This pencil, when applied lightly to the paper, will blend with a tortillion. It is similar to Col-erase in that regard, but it is a heavier pigment: Its blend is not quite as smooth. However, you have a much larger selection of colors to choose from (72 for the Studio line and 120 for the Artists line).

For darker applications, these pencils will cover well, but are lighter and more transparent than Prismacolor. For very bright colors, I will always prefer the waxy pigment over the clay-based pencil.

These two drawings show how versatile these pencils can be. Both of them have areas of smooth blended color as well as heavy, built-up color. In many ways, these pencils give you the best of two worlds. They are a very popular pencil in my studio.

This drawing of Taylor has a lot of blending to it. The entire background is a number of blue and green tones, layered together and blended out. The skin tones have also been blended with a tortillion to achieve the smooth look.

The shirt was done with heavy application to create the smooth, dark tones. Another difference between Derwent and Prismacolor is that since the Studio pencils do not have wax in them, they will not "bloom," or get cloudy. For that reason, I leave them unsprayed, because sometimes a blended area can appear darker after spraying.

TAYLOR AND HER
BAND-AID
Derwent Studio pencils
on no. 1008 mat board
16" x 20"
(41cm x 51cm)

The illustration of LeAnne in the mirror has been done much the same way. You can see areas of blended tone, as well as heavily applied pencil color. The towel in the background is a combination of the two. I applied a layer of Burnt Carmine first and blended it out until it was smooth. I then sharpened my pencil point and applied vertical pencil marks to represent the terrycloth.

Layered technique

Blended technique

Burnished technique

ANNIE IN THE MIRROR
Studio pencils on no. 1008 Ivory mat board
16" x 20" (41cm x 51cm)

NOTE —

Derwent Studio pencils can give you dark, burnished color as well as soft, blended hues. The soft colors have been blended with a tortillion. It is important to keep your tortillions separated after you use them, because they will be soiled by the last color you use. These colors do not need to be sprayed when done.

The following group of drawings were done with the Studio line of pencils. Each portrait has its own unique characteristics and techniques applied to it. You can see how varied the look can be, from deep tones to subtle, light blending.

COLORS USED

Skin tones. The face tones are made with Terra Cotta, Copper Beech and Burnt Carmine blended into the paper color with a tortillion. The lips are Madder Carmine: I used this color to warm the cheeks and tip of the nose also.

The glasses. The glasses are a combination of Chocolate Brown and Burnt Carmine with White highlights streaked in. I softened all of the tones with a tortillion. The rims are created with Steel Gray, Black and White.

The shirt. The shirt is a combination of Bottle Green and Black blended together.

Hair. The hair is a layering of Chocolate Brown, Copper Beech, Burnt Yellow Ochre, Black and White.

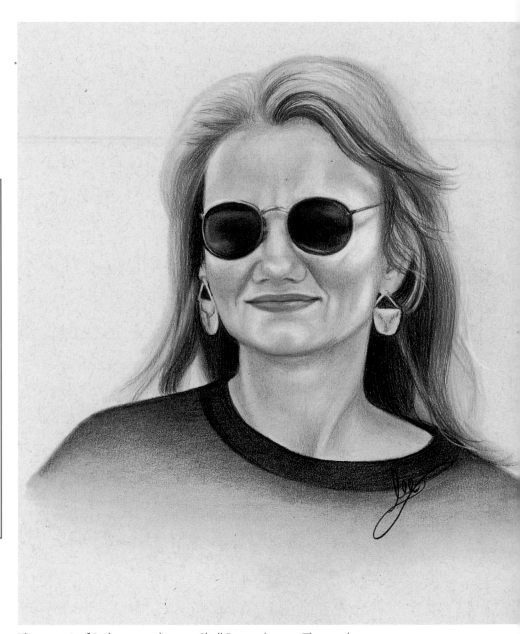

The portrait of Barbara was done on Shell Renewal paper. The peach tone of the paper really helped me acquire the soft skin tones that I wanted. I like the contrast of tones in this one. It has the rich dark hues of the glasses, the soft skin tones and the somewhat textured appearance of the shirt. I chose to leave a background out on this one.

BARBARA
Studio pencils on Shell Renewal paper
14'' x 18'' (35cm x 46cm)

Derwent colored pencils have a unique formulation that allows a heavy application of color as well as a soft, blended look. This drawing incorporates both of these qualities.

To achieve a smooth, blended look, the pencil lines must be put down lightly and evenly first and then blended out with a tortillion. It is important to use a paper color suitable for the skin tones.

COLORS USED

Skin tones. The skin tones are the same as the formula for Barbara, but with the warm glow of Deep Chrome Yellow added in. I used this color as well as Burnt Carmine and Lemon Cadmium for the background. The left side of the face has more of a yellow tone to it. The right side seems cooler with more Madder Carmine.

The clothes. The outfit is Ivory Black, with Sky Blue for the highlights.

The oval mat. It is important to the look of this portrait by balancing the dark tones and making the light tones stand out.

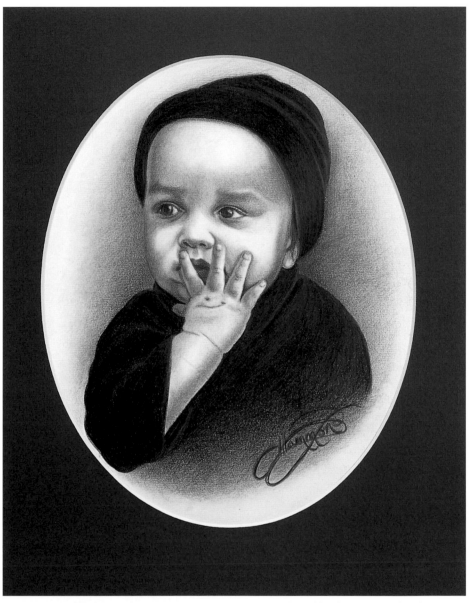

This portrait of Sydney is done on no. 1008 Ivory mat board. Unlike the portrait of Barbara, I used a lot of background color and repeated the colors in the skin tones. The whole drawing takes on a warm glow because of it.

Again, note how these pencils go from very light to very dark. The black outfit contrasts sharply against the smooth, light baby skin. (We laughed at this outfit, saying she looked like the world's youngest cat burglar!)

SYDNEY
Studio pencils on no. 1008 Ivory mat board
8'' x 10'' (20cm x 25cm)

Composition

Composition can be very important to your drawing. *Composition* is the balance of your subjects on the paper, as well as the distribution of lights, darks and colors around the page. Your work should be evenly balanced, not top or bottom heavy, and you must finish your work in an eye pleasing format.

Sometimes the photo you are working from will not lend itself to any particular format. Too much may be going on in the picture, forcing you to select just certain elements from it to draw. It will be up to you, as an artist, to create the composition yourself.

The picture of Sam is a good example of this. I eliminated clutter from the photo I was working from and isolated just him and the baby. Although their positioning falls into a triangular composition, I used some shading in the background to round it out into more of an oval.

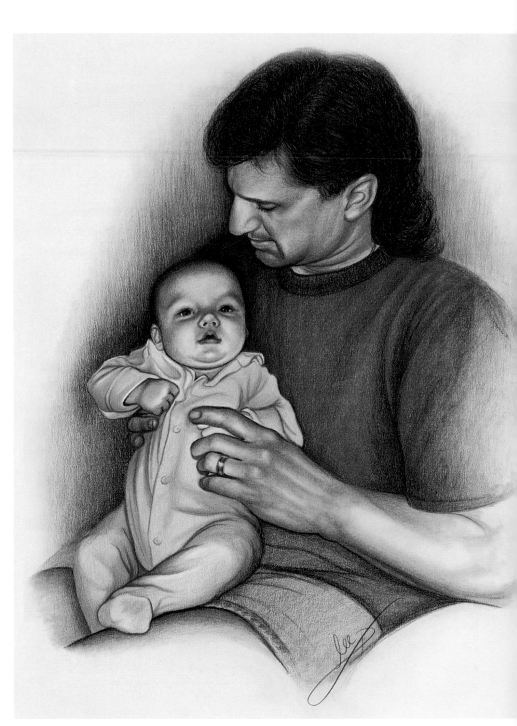

GRAMPY SAM
Studio pencils on no. 1008 Ivory mat board
16'' x 20'' (41cm x 51cm)

COLORS USED

Skin. Chocolate Brown, Burnt Carmine and Terra Cotta

Hair. Chocolate Brown, Ivory Black and White

Shirt. Bottle Green and Ivory Black

Baby clothes. Jade Green, Turquoise Blue and Indigo Blue

Background. Indigo Blue and Ivory Black

NOTE —
For more information on composition, refer to my book *Lifelike Portraits From Photographs.*

Studio Pencils Step by Step

Now it is your turn to try the Studio pencils for yourself. Let's draw this portrait step by step. I have quite a pinkish complexion, so I chose no. 1030 Pastel Pink mat board for this drawing.

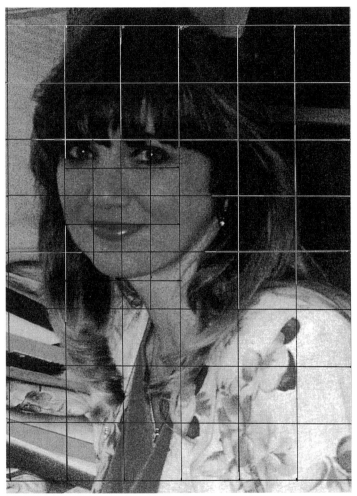

A graphed photo.

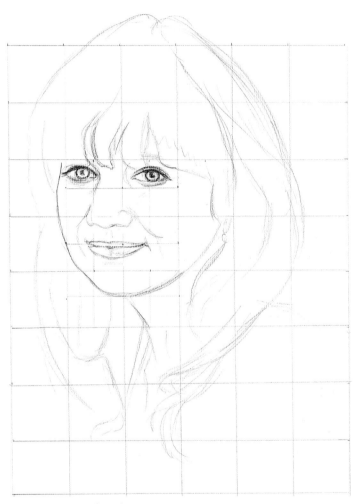

Draw an accurate line drawing.

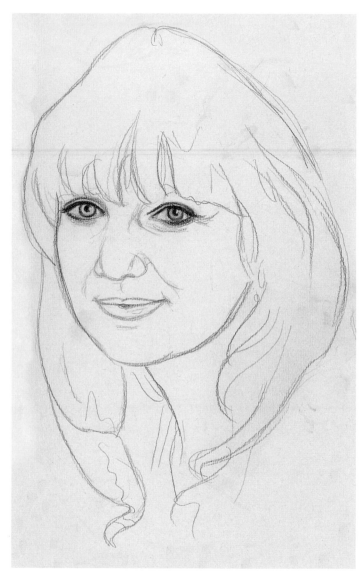

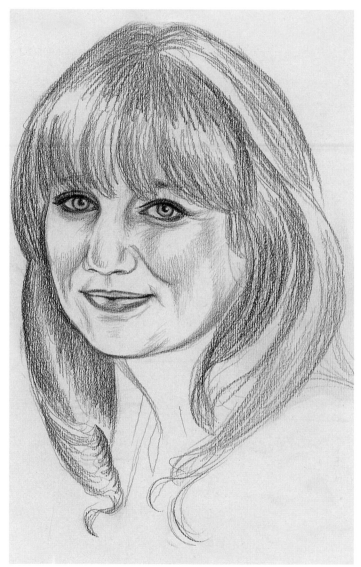

1 Replace your graphite lines with a brown tone called Copper Beech. (Remember, blending graphite into color accidentally will gray down the colors, making them appear dirty.)

2 Next, draw the eyes, applying the pupil with Ivory Black, as well as the outside edge of the iris. Add Black to the lash lines and lid crease.

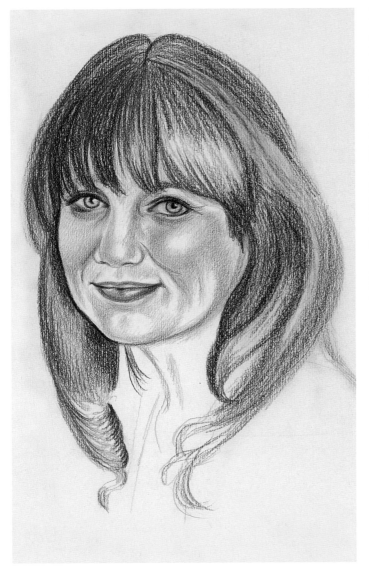

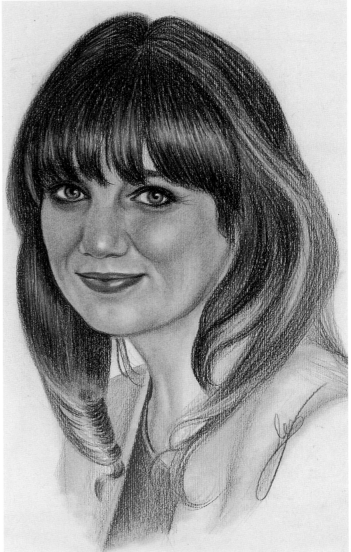

3 With Chocolate Brown, begin the tone of the hair, looking for all of the highlight areas and leaving them a bit lighter. This helps establish the shape of the hair as well as the light source.

With Burnt Carmine, add some tone to the shadows of the face to start creating the roundness. Also add the same color to the lips.

4 With Terra Cotta, lightly apply more color into the face. Be sure to put some on the forehead, under the hair. Add some Carmine Red to the lips. At this stage, don't use a tortillion at all. You can see how important it is to apply the pencil line smoothly: No amount of blending will smooth out rough, uneven pencil lines.

Go back to the hair and add more Chocolate Brown to build up the color. Also add Yellow Ochre to give it some blonde highlights. Use quick strokes to keep the pencil lines thin and natural looking.

Drawing With Watercolor Pencils

Watercolor pencils are a unique way to combine the application of colored pencils with the look of traditional watercolor painting. Once the pencils have been applied to the paper, the addition of a little water with a wet paintbrush turns your drawing into a painting.

Since the technique and application used with watercolor pencils is so different than other color pencils, it is helpful to go back to the basics.

The sphere is the best way to practice a new technique. Use these illustrations as a guide to help you learn the process before you attempt a full portrait project.

To create a portrait with watercolor pencils, you begin very much the same way as you would for a traditional colored pencil drawing. Always start with an accurate line drawing. This is what your colors and tones will be built on.

The color of your portrait is also done like your other colored pencil projects. The real difference is when you apply the water.

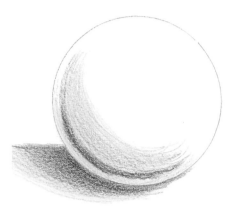

Using Blue and Magenta, I lightly drew the characteristics of a sphere. The pencil is applied very light, since the application of water will deepen the colors considerably. By overlapping the two colors, I created a purple color.

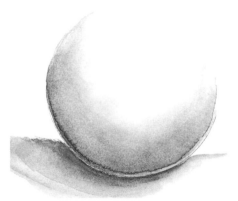

With a damp paintbrush, I was able to blend all of the colors together. In the full-light area, the pigment has been blended with water to fade to the white of the paper color. (These have been drawn on watercolor board.)

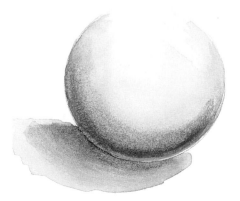

This is a sphere done with flesh tones. I used Dark Brown, Burnt Carmine and Terra Cotta. A hint of Black was used in the cast shadow, directly under the sphere.

Drawing With Watercolor Pencils Step by Step

Watercolor pencils combine the effects of colored pencils with the look of traditional watercolor. A little water applied with a fine brush will melt the drawing down into a painting. The following is a step-by-step portrait of a man drawn with watercolor pencils.

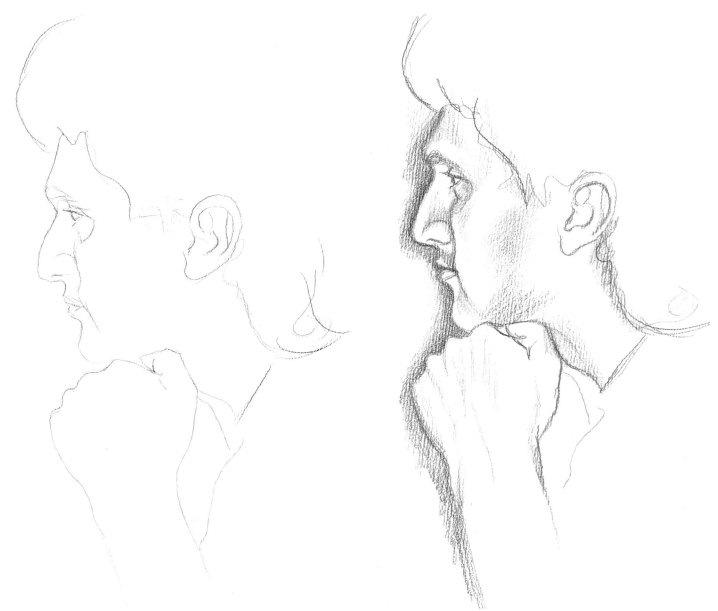

1 Draw an accurate line drawing with graphite.

2 Lightly start the skin tones with a layer of Terra Cotta. Use a small amount of Dark Brown along the jawline and above the upper lip. To help the edge of the face stand out, use Indigo Blue behind it.

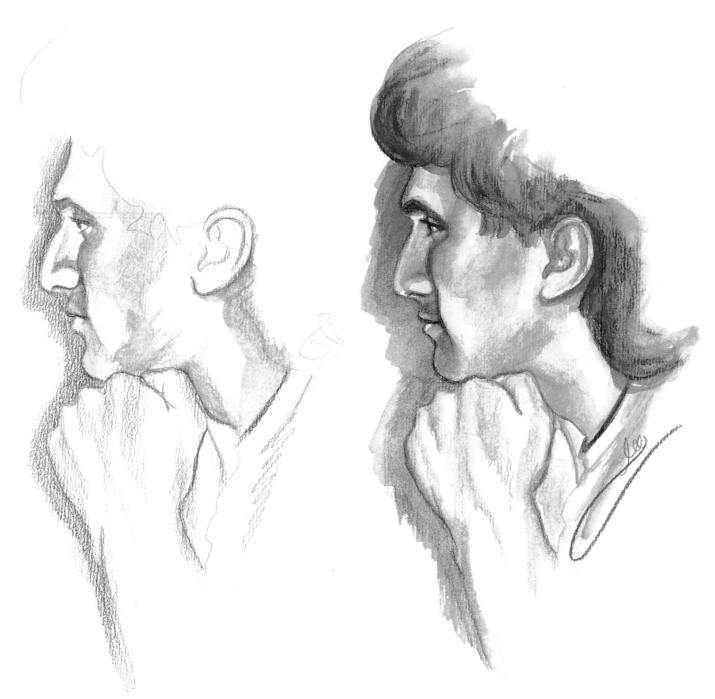

3 Softly blend the facial tones with a damp paint-brush. Don't use a lot of water, just enough to hydrate the pigment into a wash.

4 To finish the drawing, use Dark Brown and Black to create the hair. Place the pencil lines going with the direction and curve of the hair. After blending the hair with a wet paintbrush, use the color on the brush to go into the shadow areas of the face, deepening the tones. By doing this, you don't have to wait for it to dry and then reapply pencil. Borrowing color from another area and brushing it in is easier, quicker and smoother.

With a wet brush, blend the Indigo Blue background. Can you see how much darker it gets with the addition of water?

COLORS USED

This piece was done using a very small range of colors: Brown, Black and Purple. I think it has a nice, fresh look because of this.

This portrait has been created on White velour paper. It is called aquavelour and is manufactured by the Atlantic Paper Company. It is actually a velour paper that has been mounted onto a piece of museum board developed for watercolor applications. Using this technique is more of a challenge than using regular watercolor paper because the water soaks in so fast, that you cannot manipulate the color as well. Because of that, it creates very hard edges, which I think is neat. I had always wanted my watercolor paintings to have a certain look to them, which I just couldn't seem to get. I almost gave up until I tried this paper. Now I'm happy.

RAY CHARLES
Watercolor pencils on mounted White velour paper
11" x 1 4" (28cm x 35cm)

Index